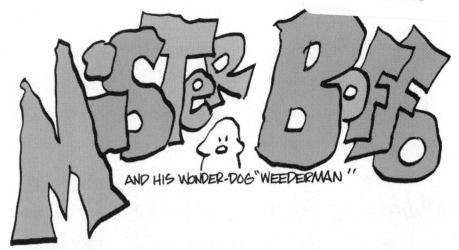

# MISTER BOFFO

AND HIS WONDER-DOG "WEEDERMAN"

# THE FIRST DECADE

To MARK
PINSKI —

BOFFO
OVERLOAD!

# THE FIRST DECADE
## by Joe Martin

**Andrews and McMeel**
A Universal Press Syndicate Company
**Kansas City**

**Send Joe Martin e-mail at:**
**jmartin@wisenet.net**
**and**
**Boffo97507@aol.com**

**or check out our home page at:**
**http://www.wisenet.net//users/boffo/boffo.htm**

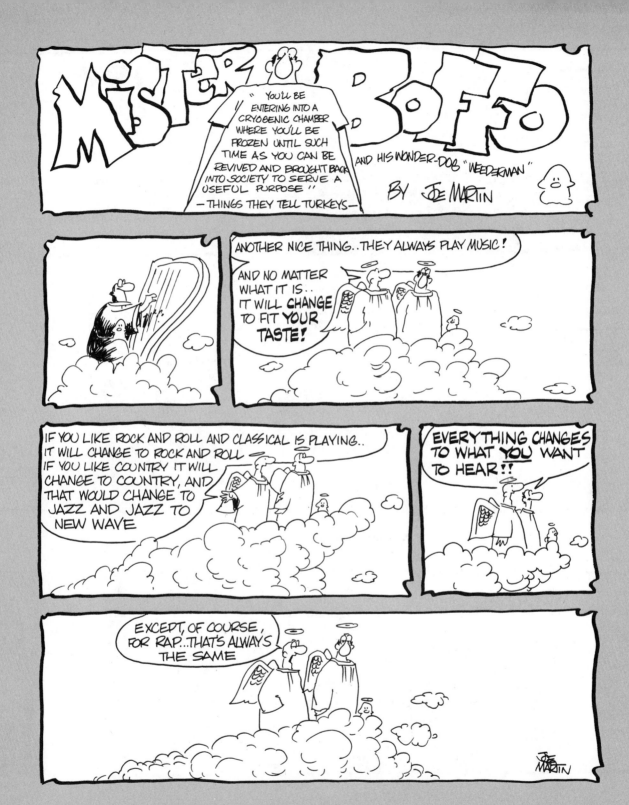

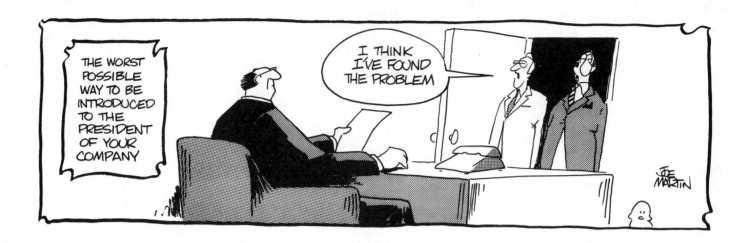

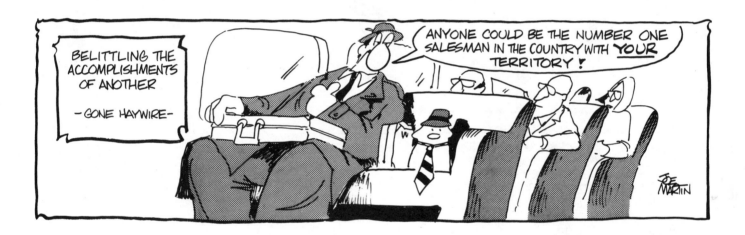

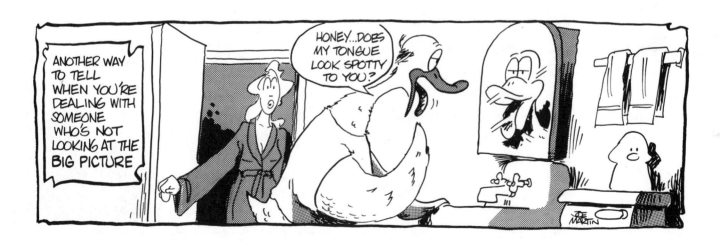

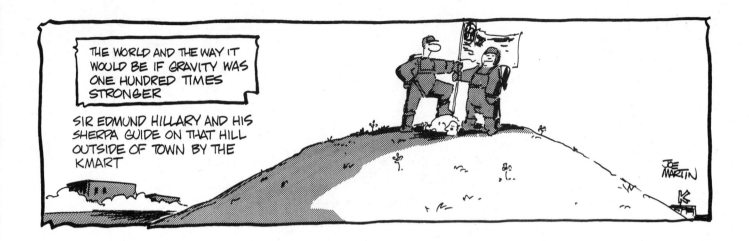

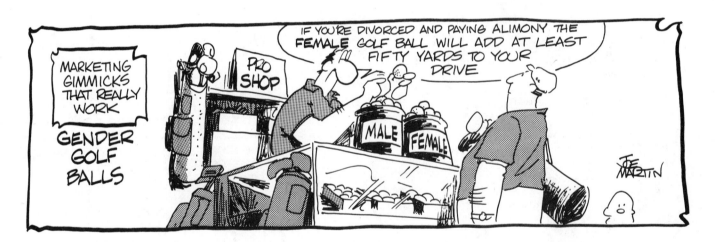

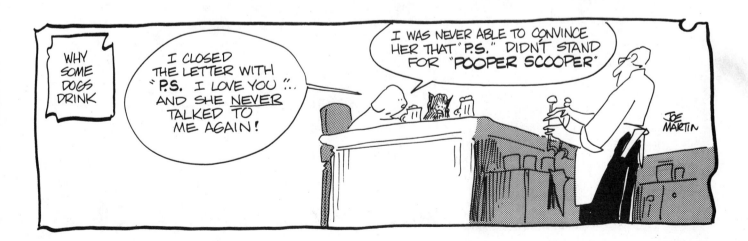

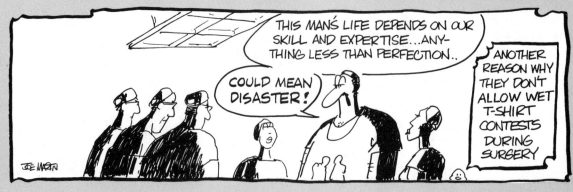

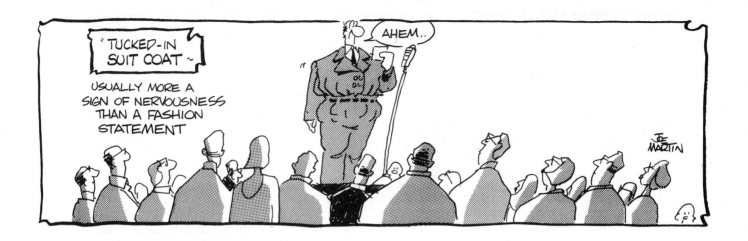

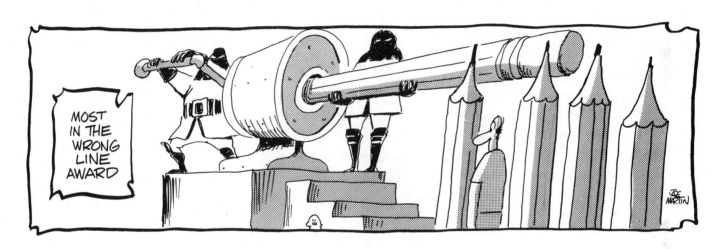

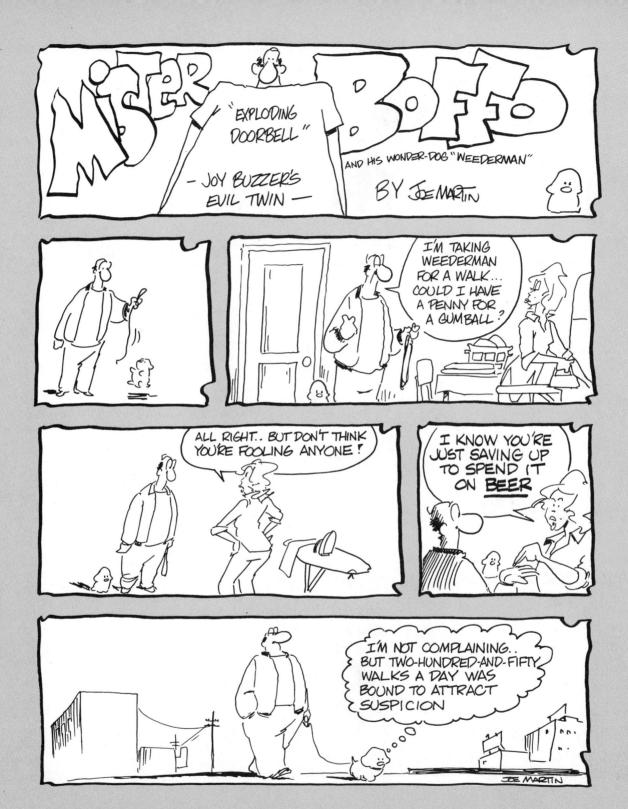

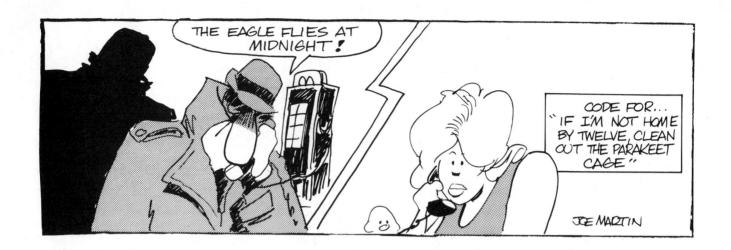

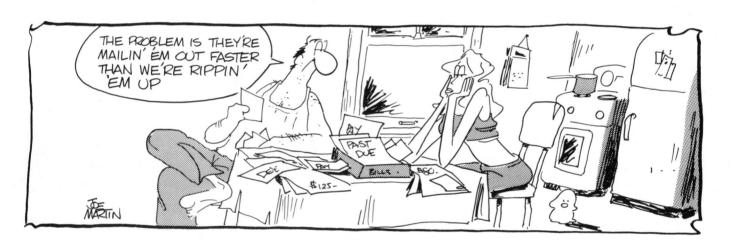

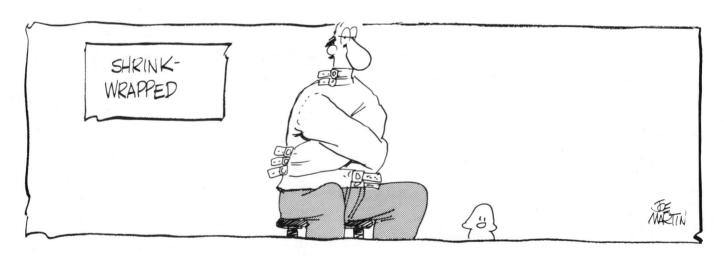

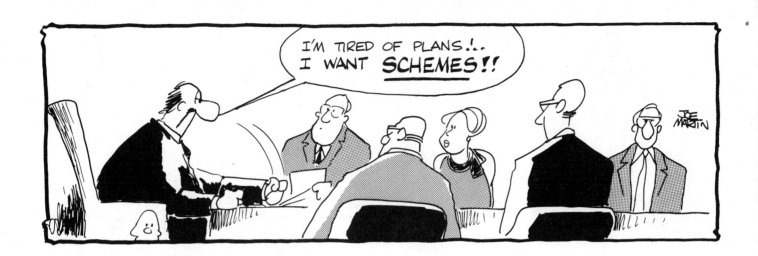

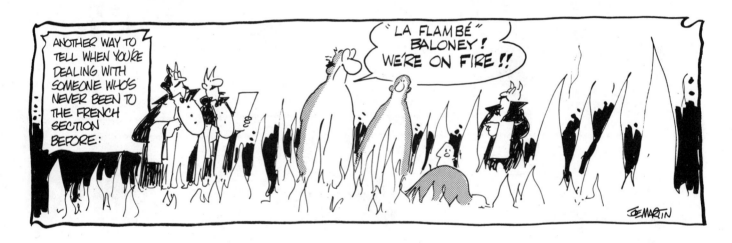

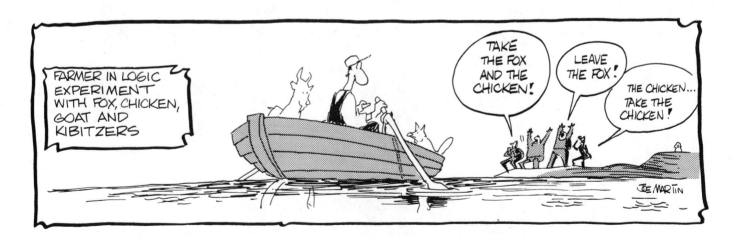

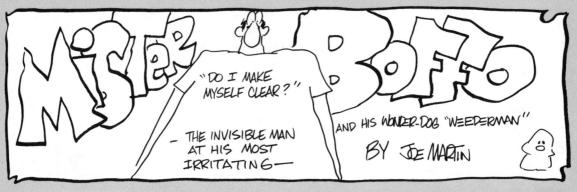

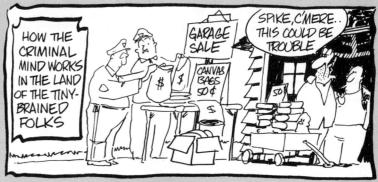

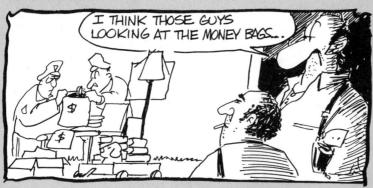

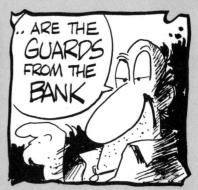

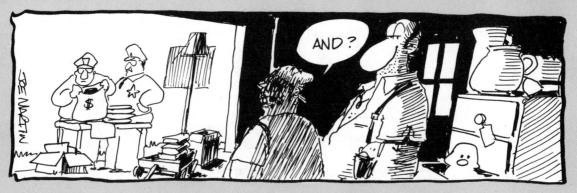

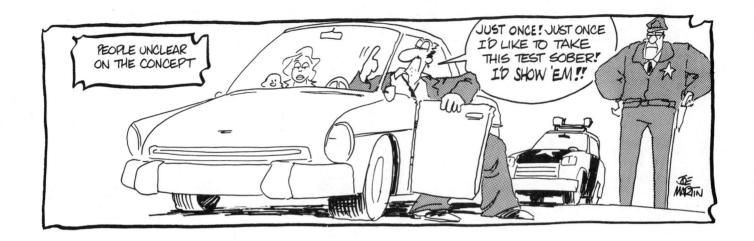

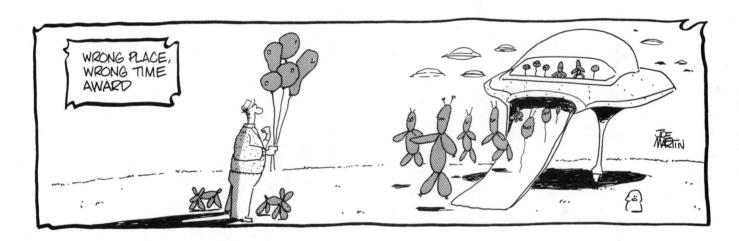

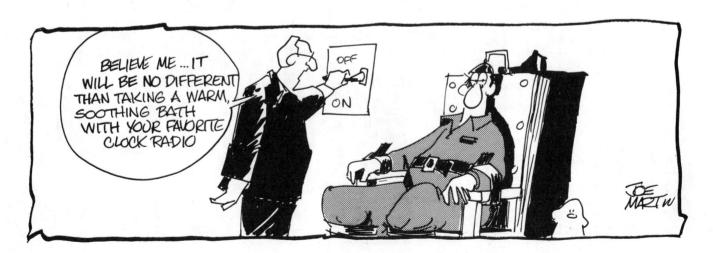

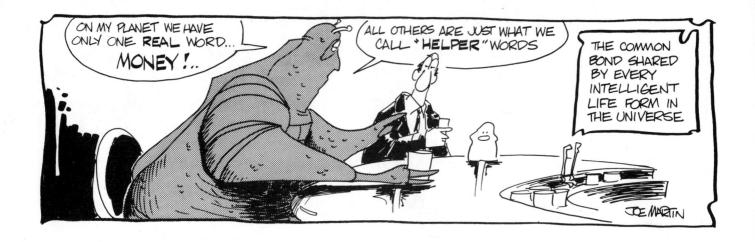

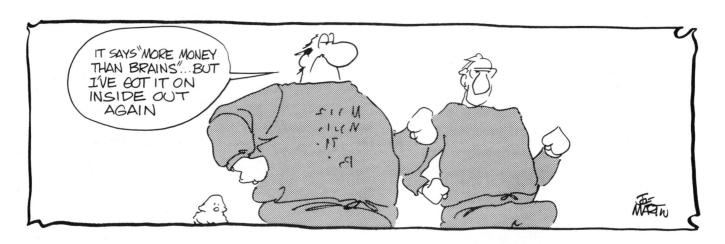

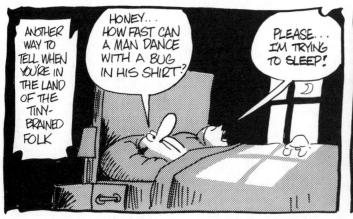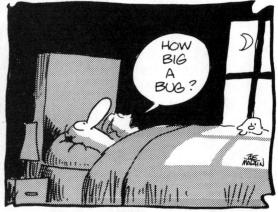

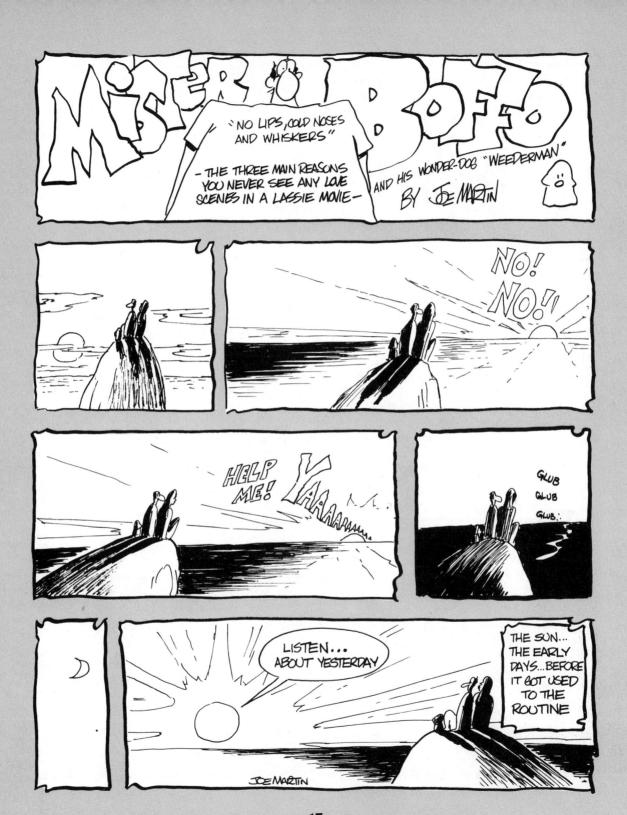

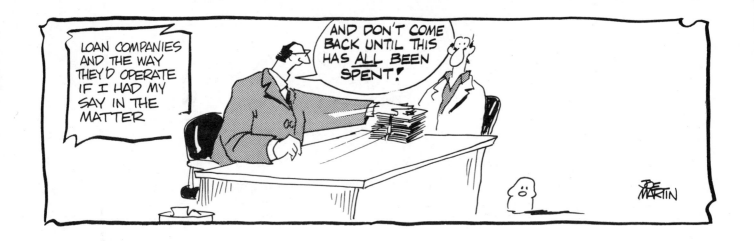

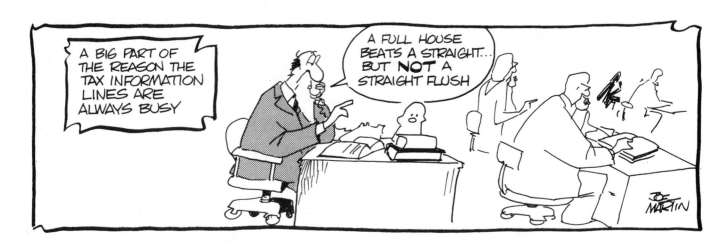

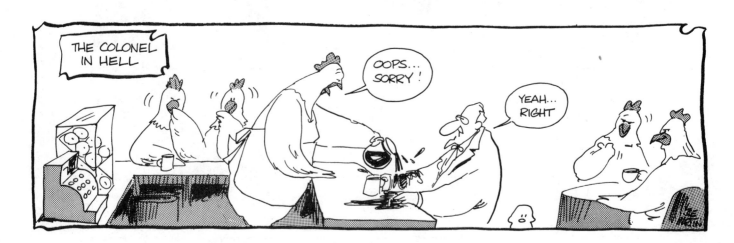

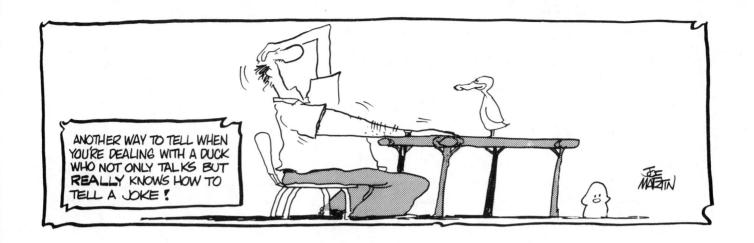

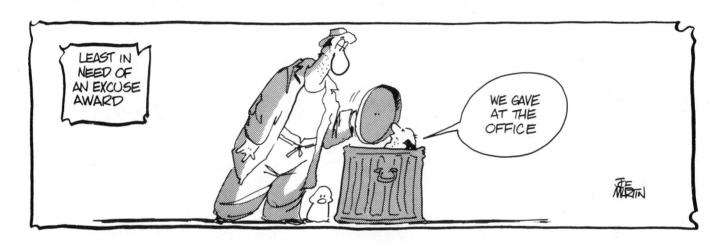

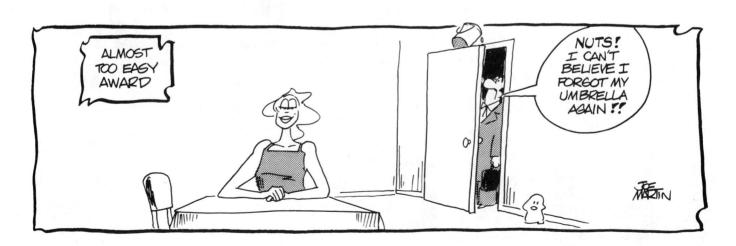

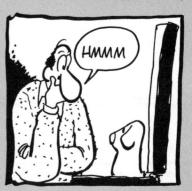

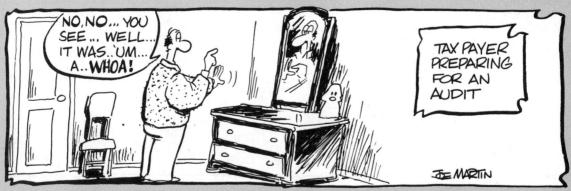

TAX PAYER PREPARING FOR AN AUDIT

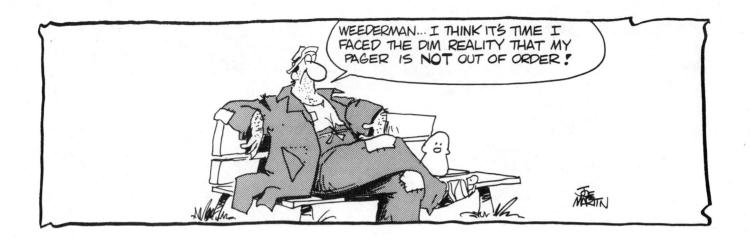

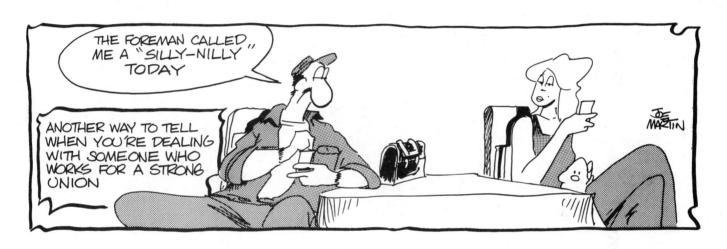

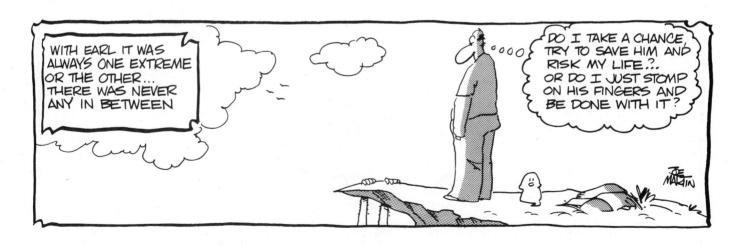

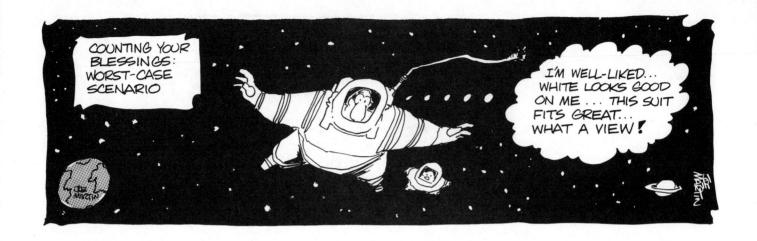

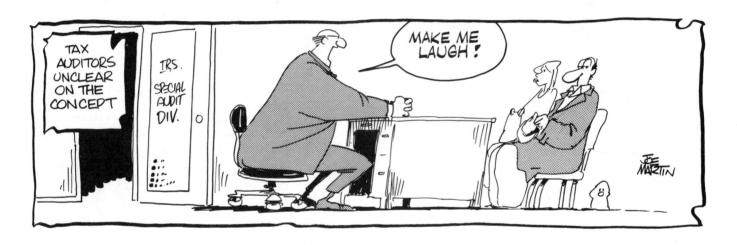

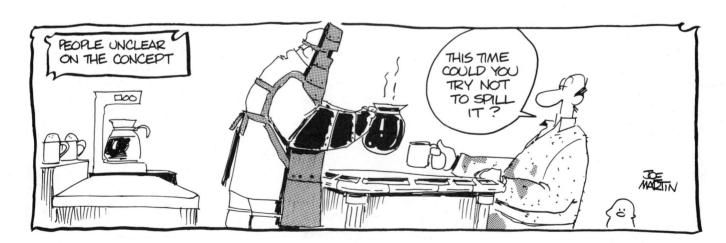

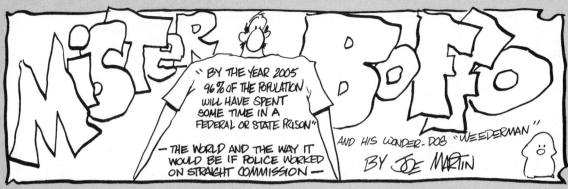

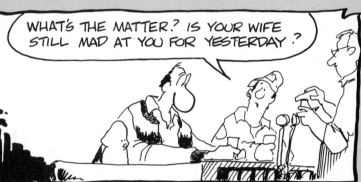

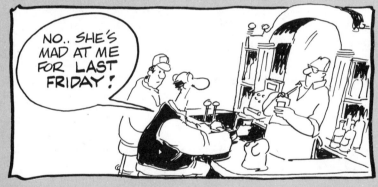

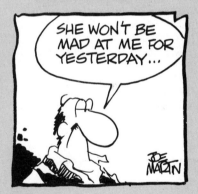

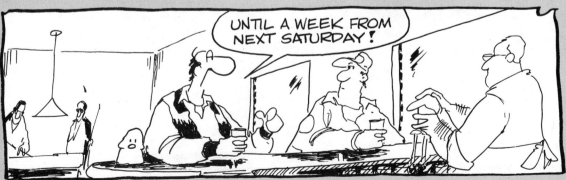

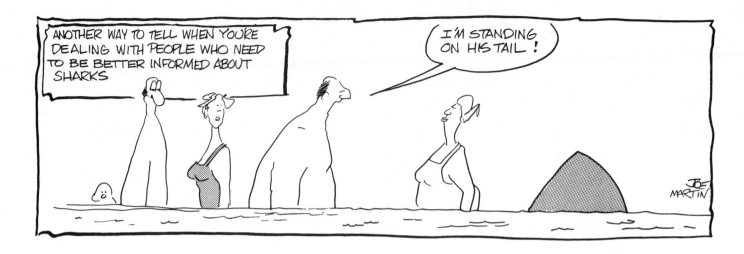

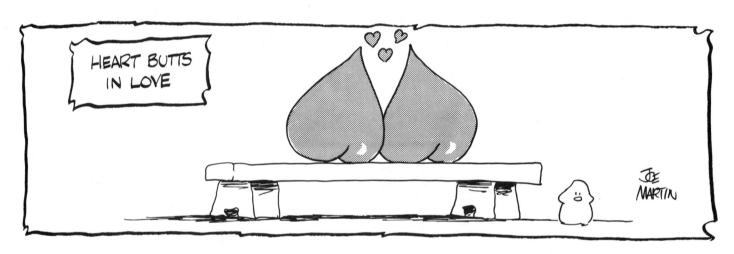

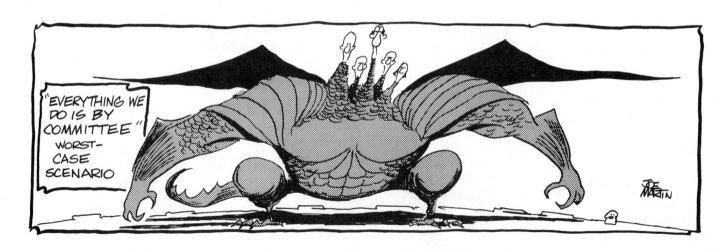

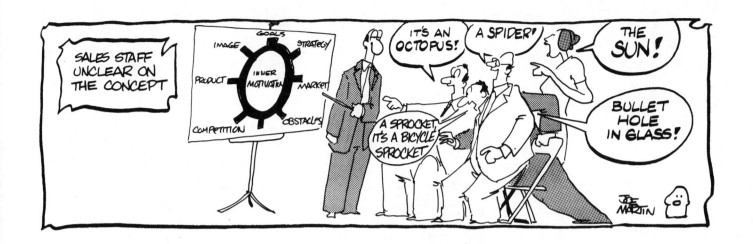

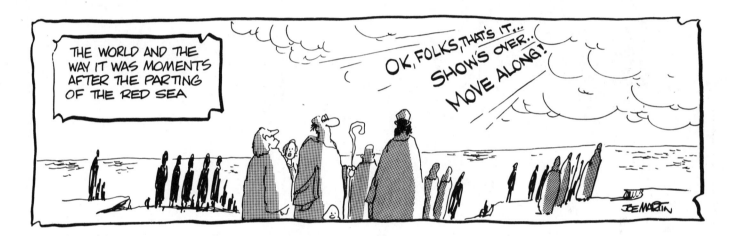

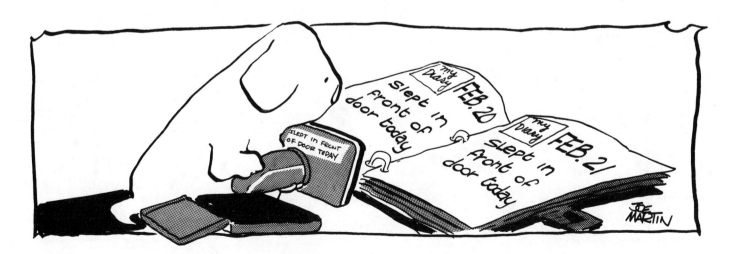

27

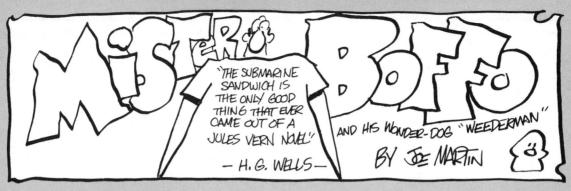

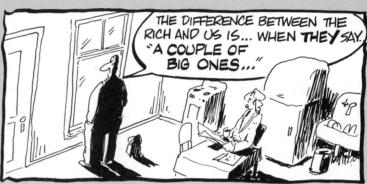

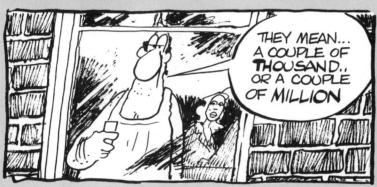

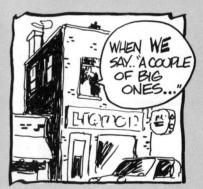

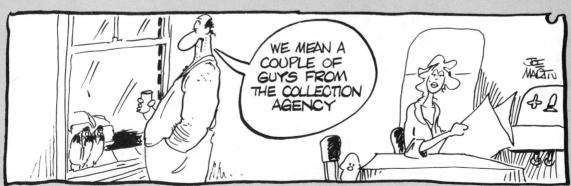

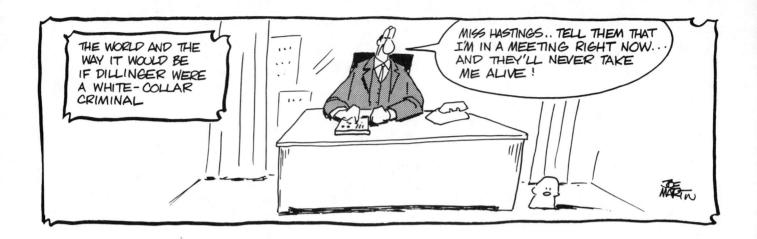

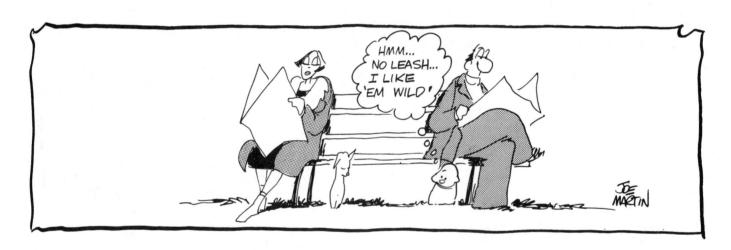

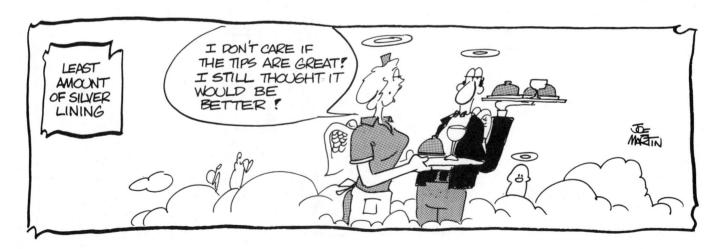

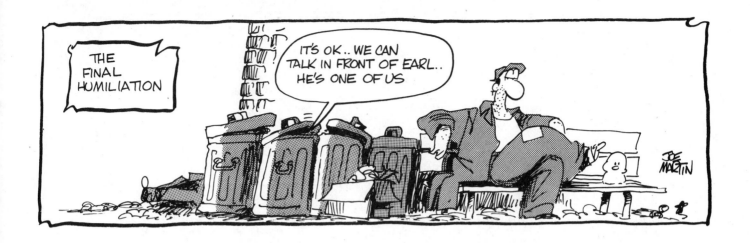

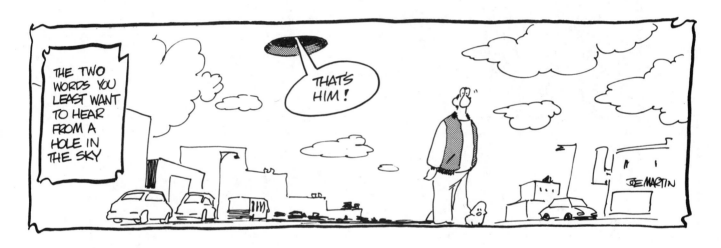

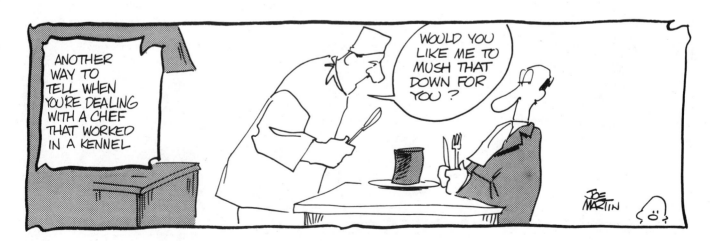

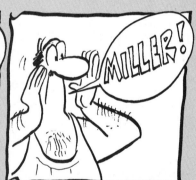

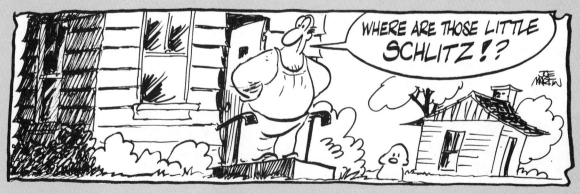

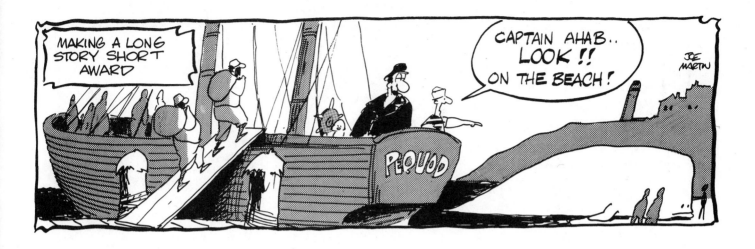

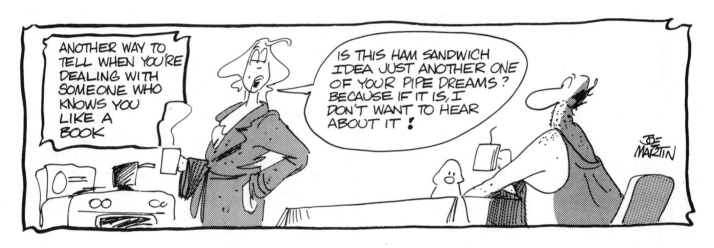

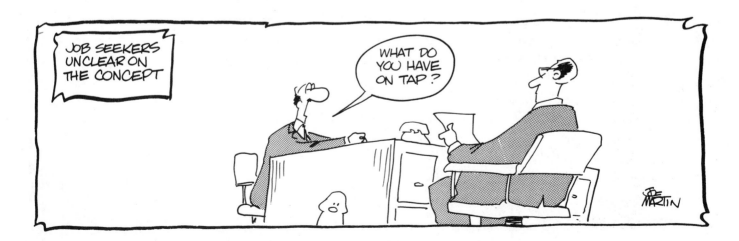

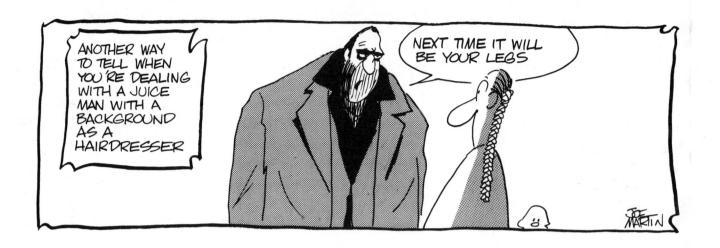

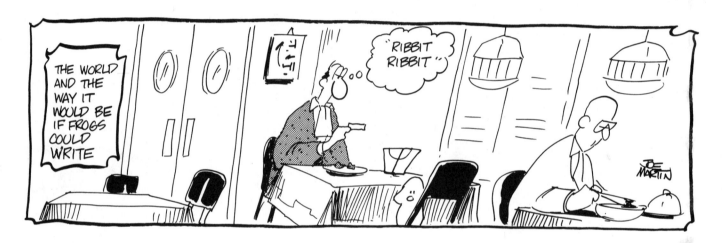

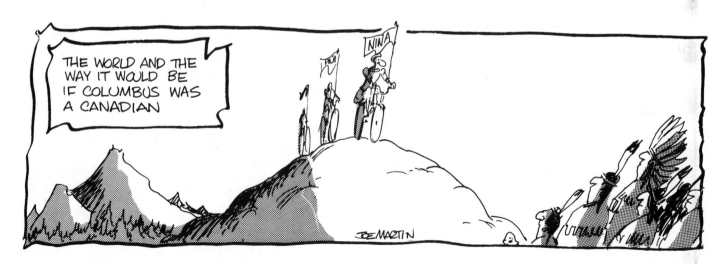

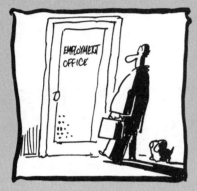
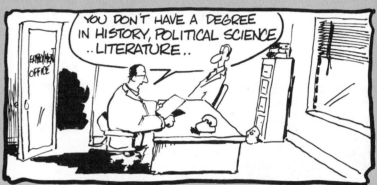

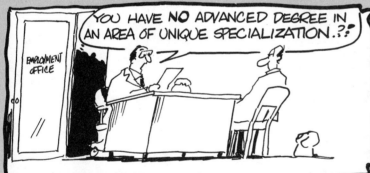
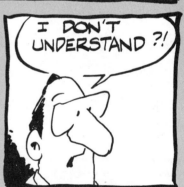

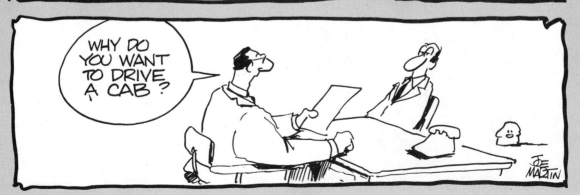

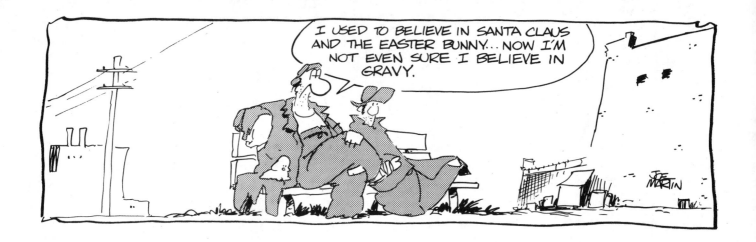

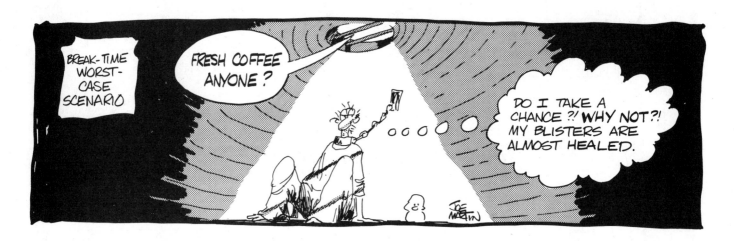

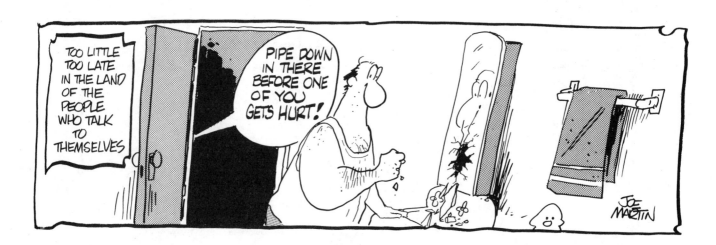

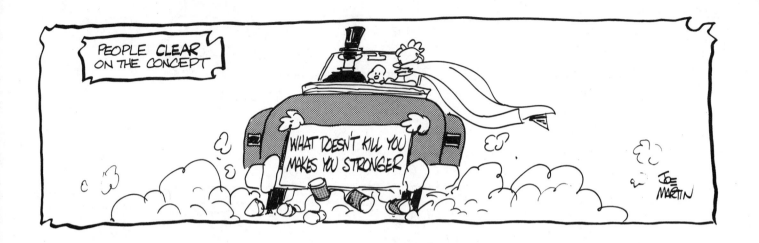

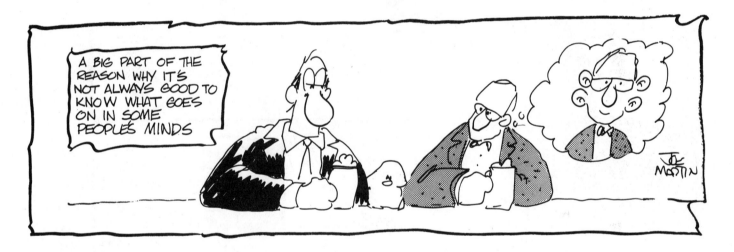

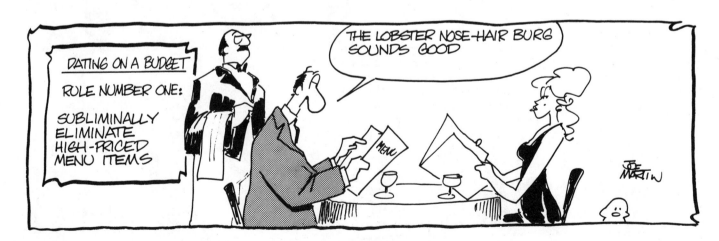

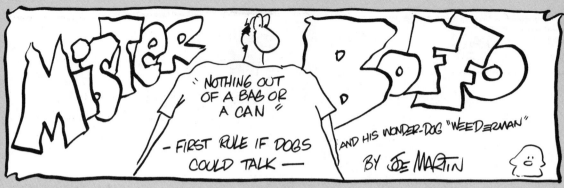

# Mister Boffo

"NOTHING OUT OF A BAG OR A CAN"

— FIRST RULE IF DOGS COULD TALK —

AND HIS WONDER-DOG "WEEDERMAN"

BY JOE MARTIN

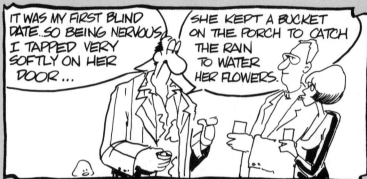

IT WAS MY FIRST BLIND DATE..SO BEING NERVOUS, I TAPPED VERY SOFTLY ON HER DOOR...

SHE KEPT A BUCKET ON THE PORCH TO CATCH THE RAIN TO WATER HER FLOWERS.

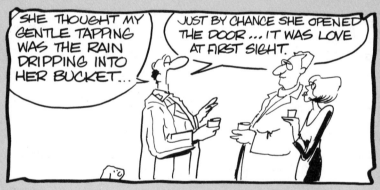

SHE THOUGHT MY GENTLE TAPPING WAS THE RAIN DRIPPING INTO HER BUCKET...

JUST BY CHANCE SHE OPENED THE DOOR...IT WAS LOVE AT FIRST SIGHT.

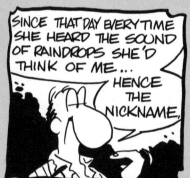

SINCE THAT DAY EVERY TIME SHE HEARD THE SOUND OF RAINDROPS SHE'D THINK OF ME... HENCE THE NICKNAME.

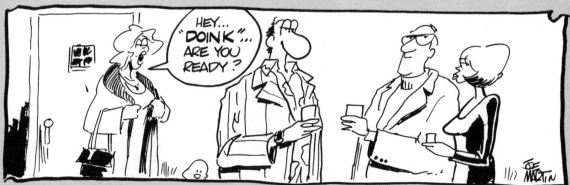

HEY... "DOINK"... ARE YOU READY?

JOE MARTIN

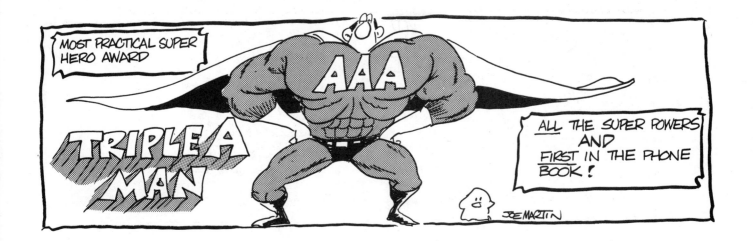

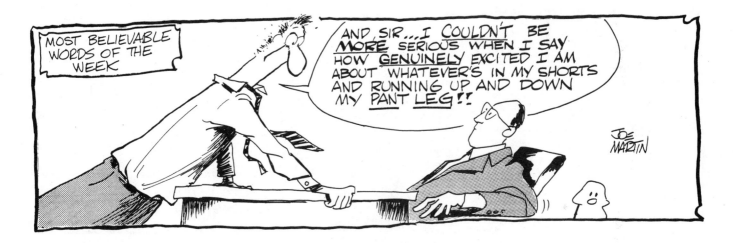

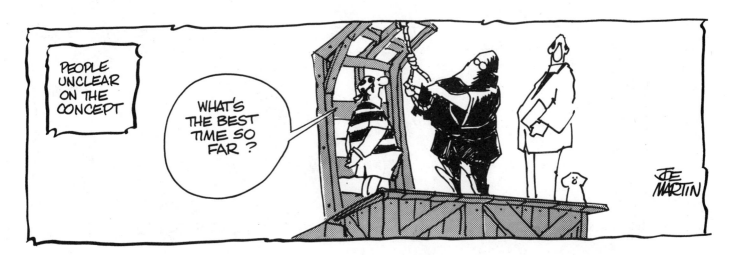

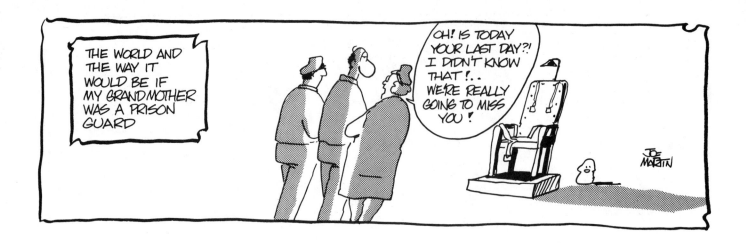

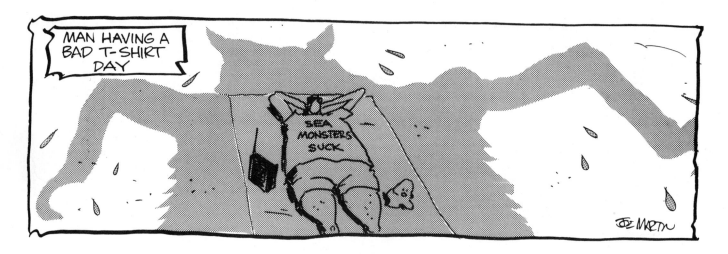

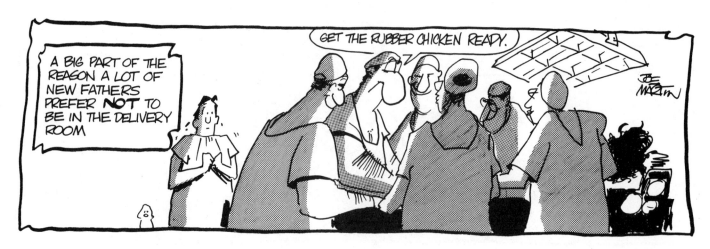

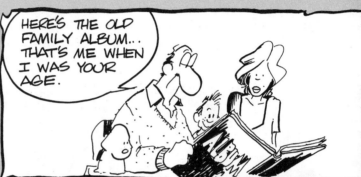

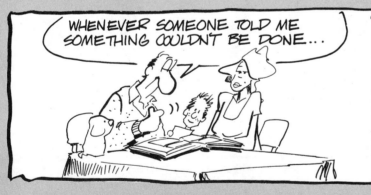

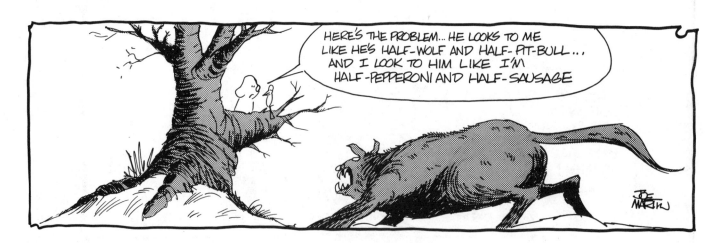

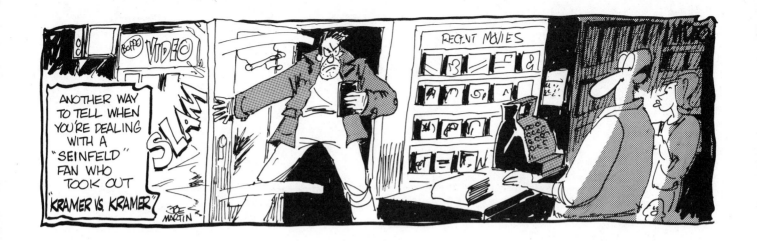

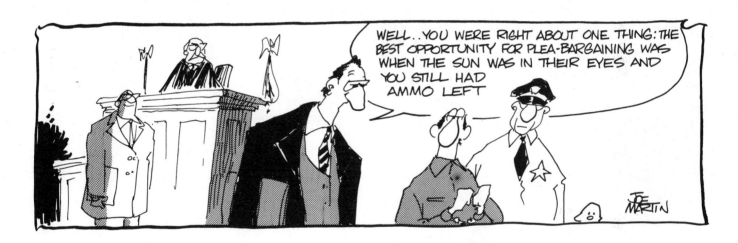

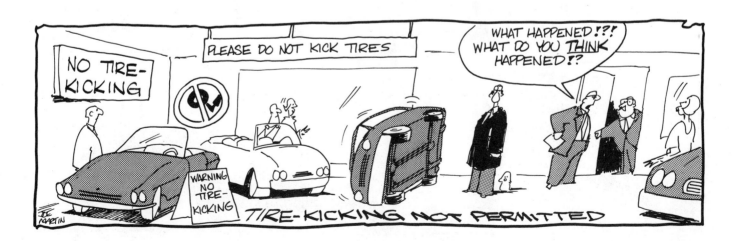

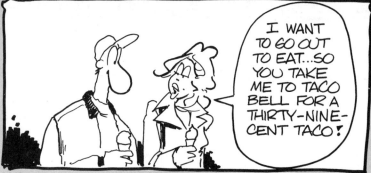

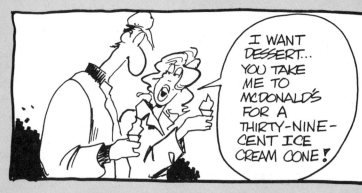

44

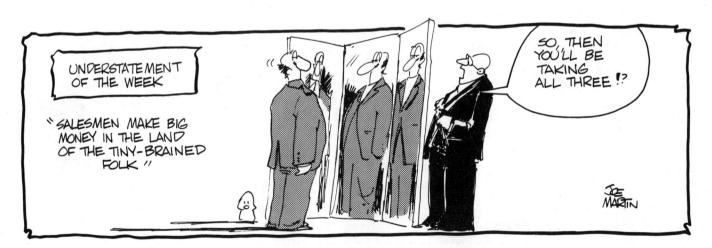

45

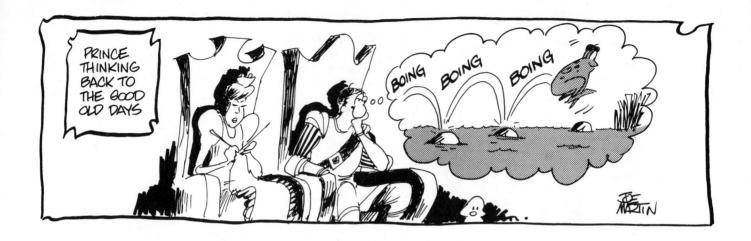

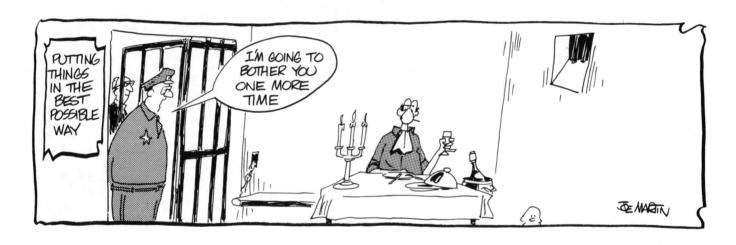

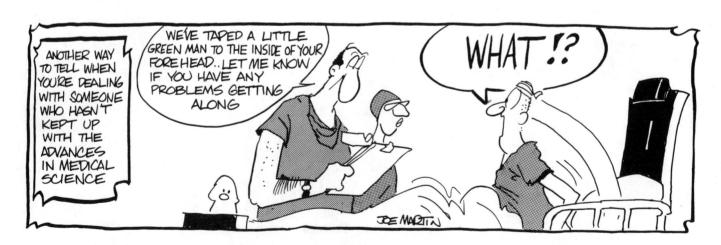

46

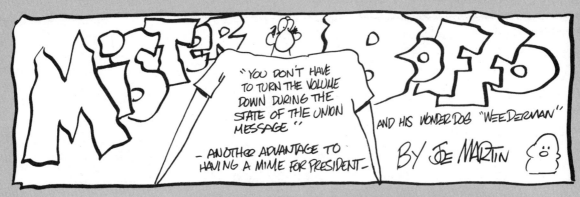

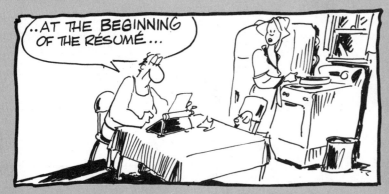

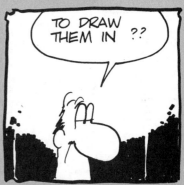

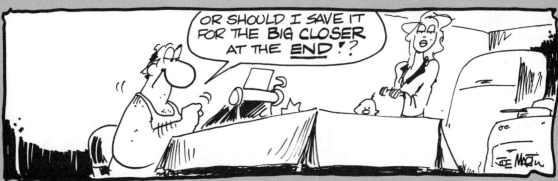

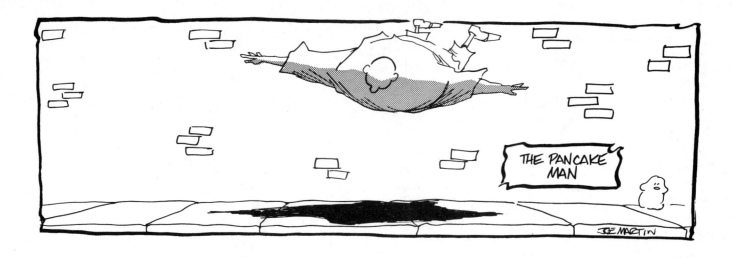

THE PANCAKE MAN

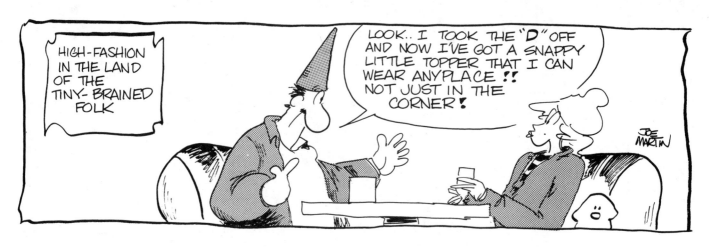

HIGH-FASHION IN THE LAND OF THE TINY-BRAINED FOLK

LOOK.. I TOOK THE "D" OFF AND NOW I'VE GOT A SNAPPY LITTLE TOPPER THAT I CAN WEAR ANYPLACE !! NOT JUST IN THE CORNER!

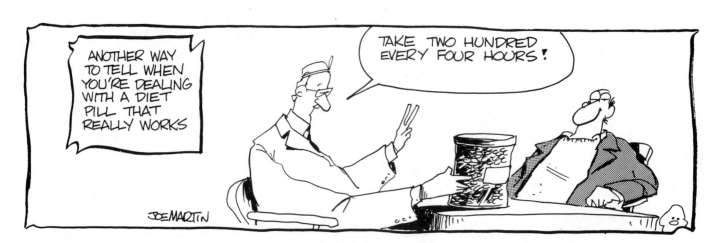

ANOTHER WAY TO TELL WHEN YOU'RE DEALING WITH A DIET PILL THAT REALLY WORKS

TAKE TWO HUNDRED EVERY FOUR HOURS!

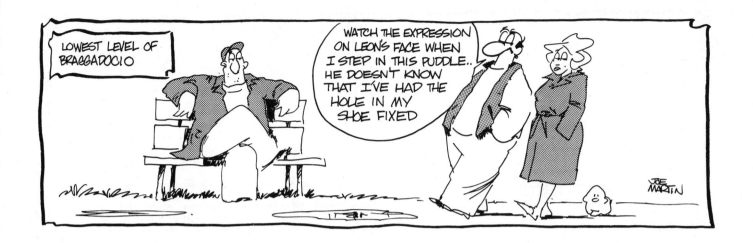

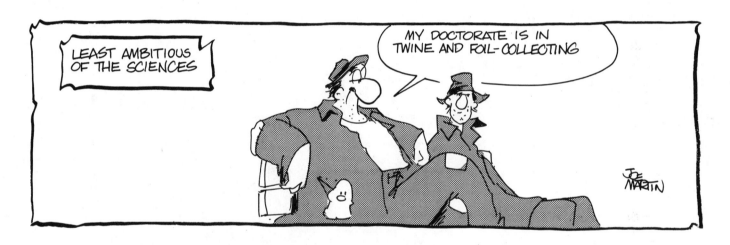

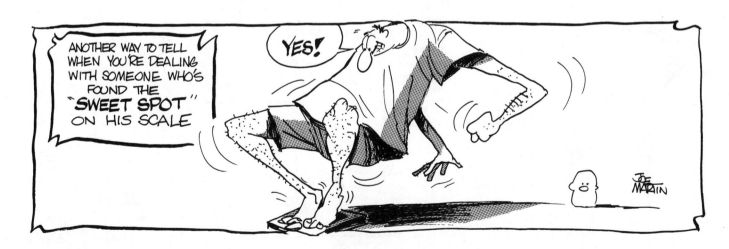

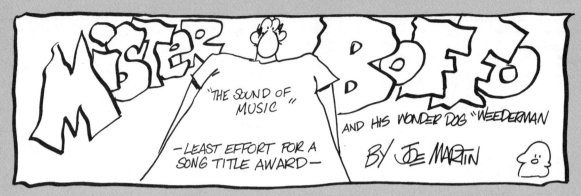

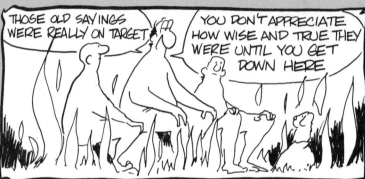

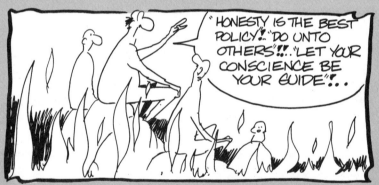

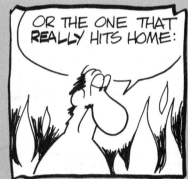

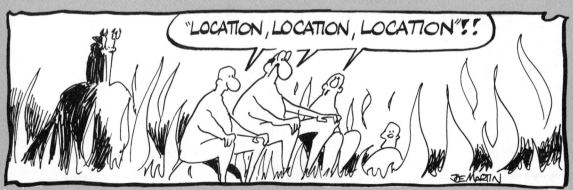

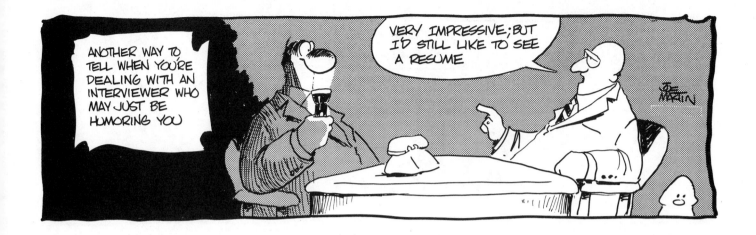

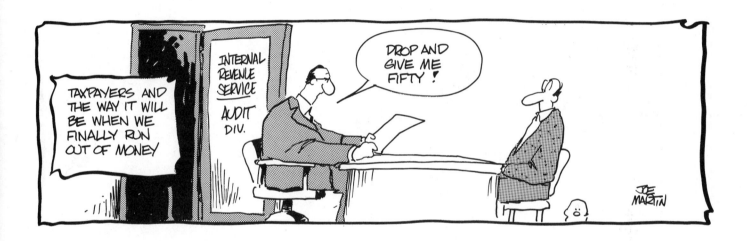

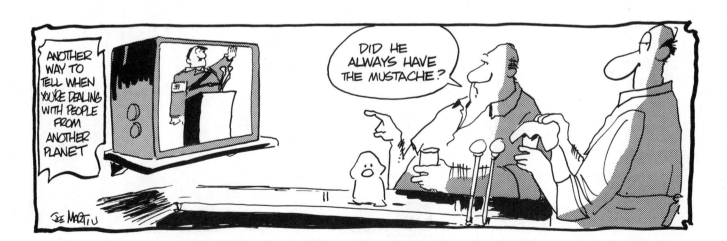

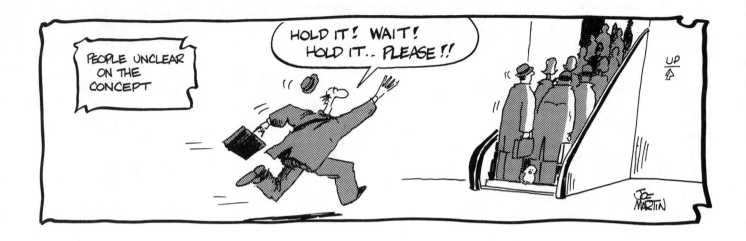

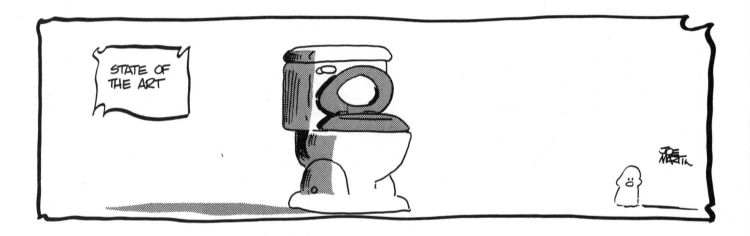

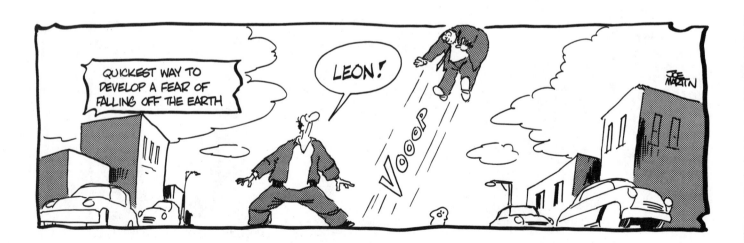

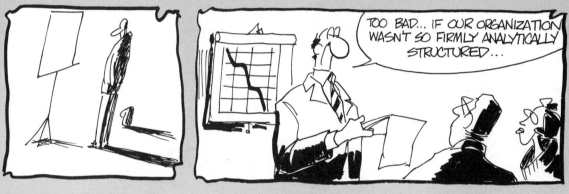

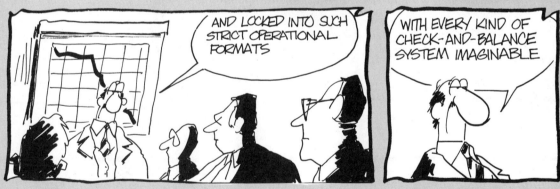

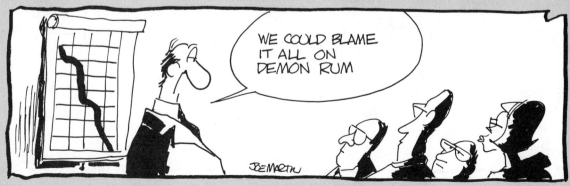

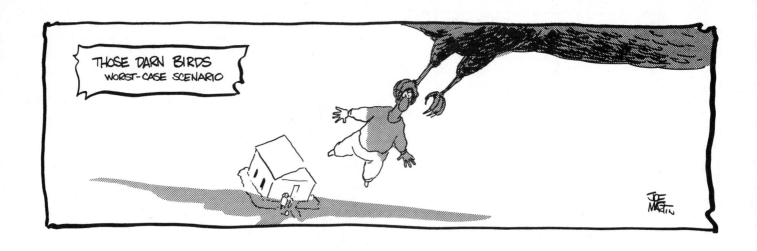

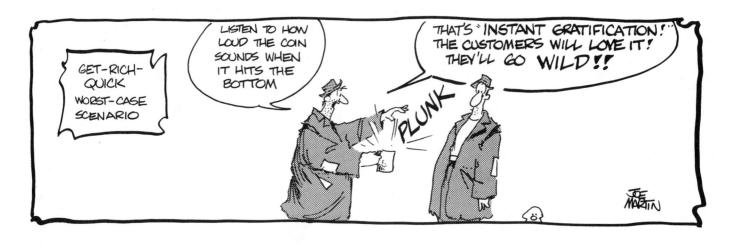

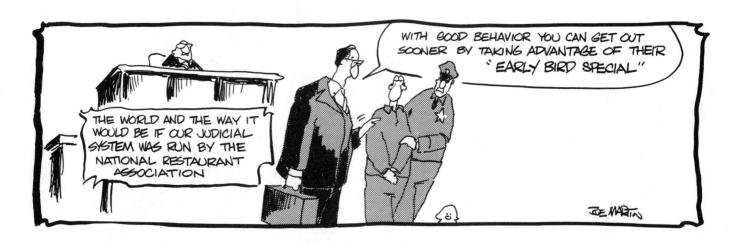

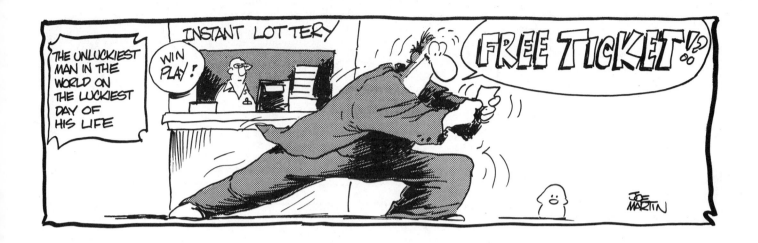

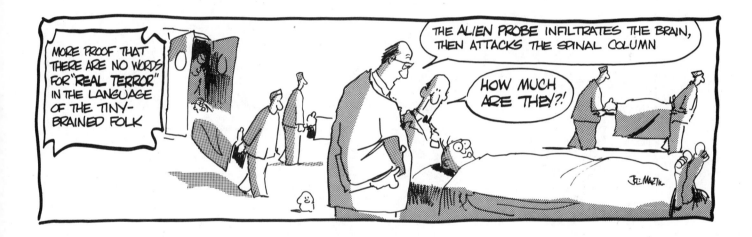

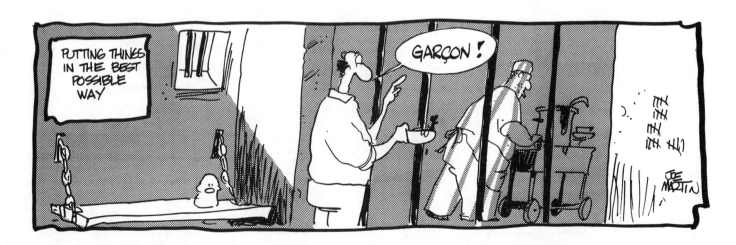

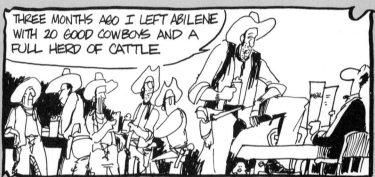

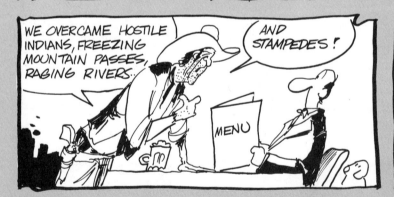

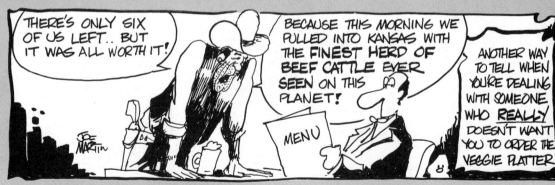

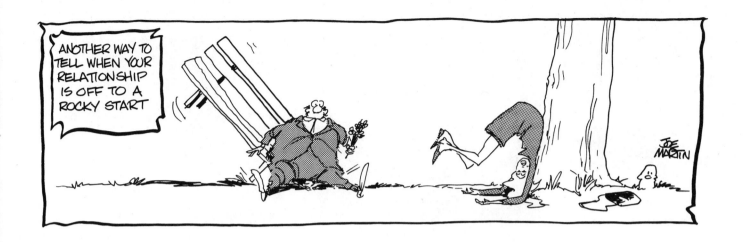

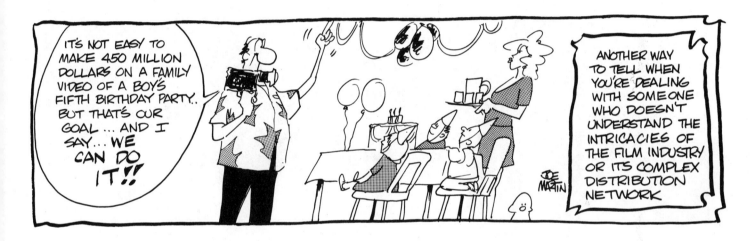

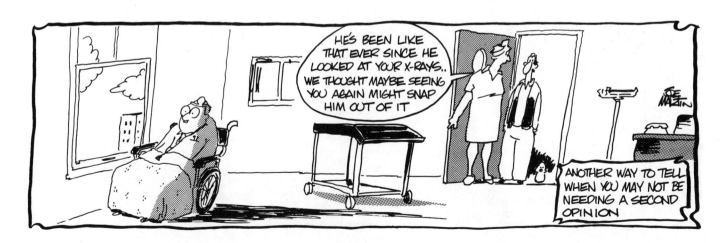

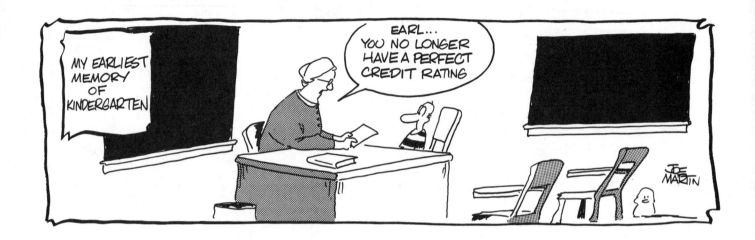

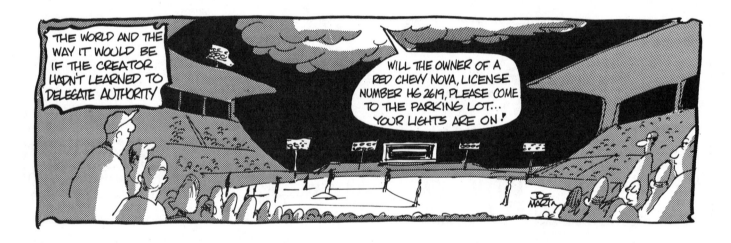

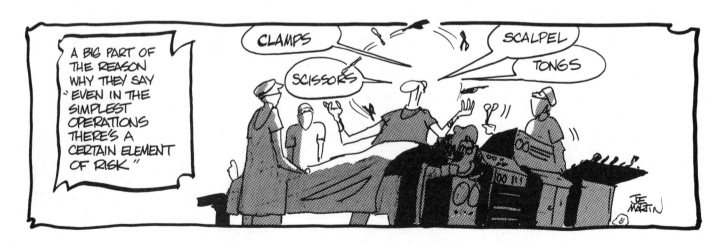

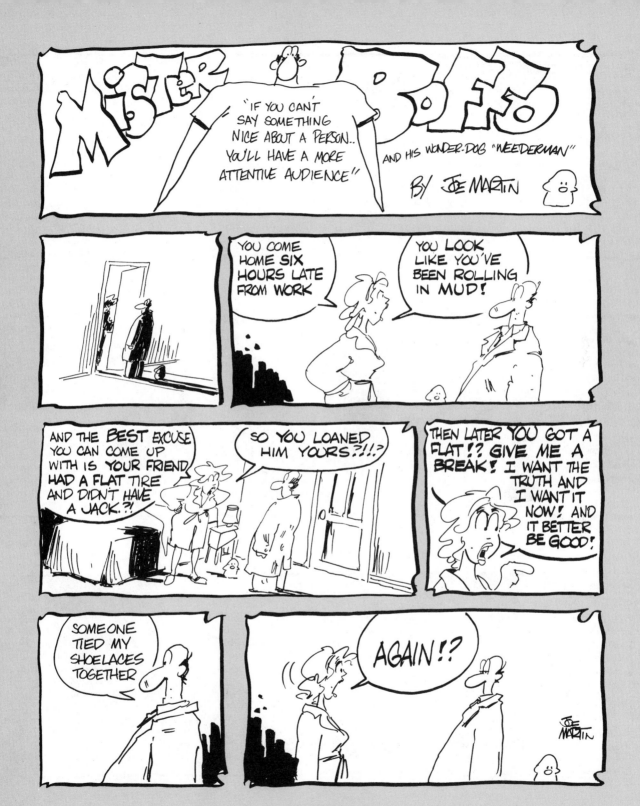

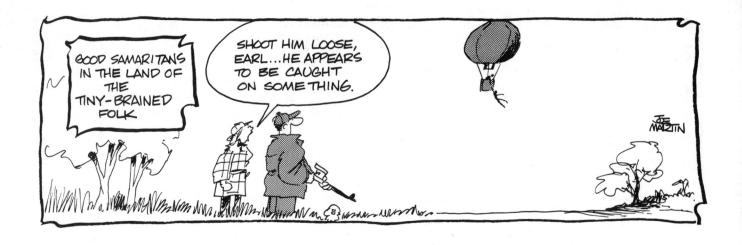

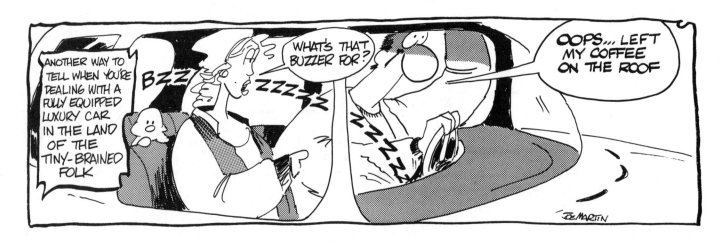

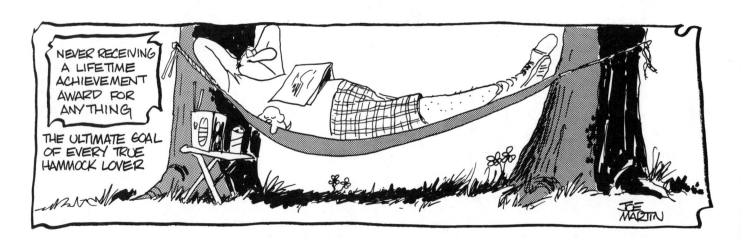

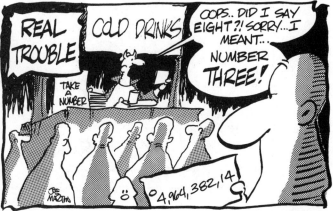

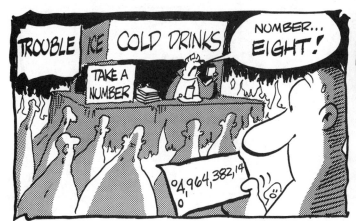

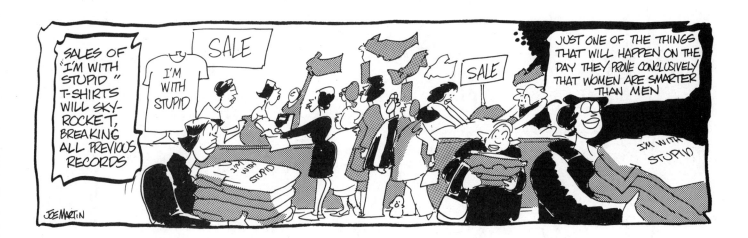

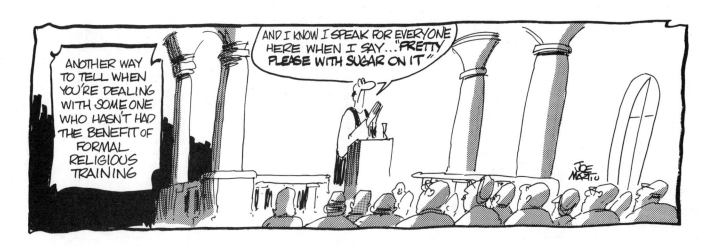

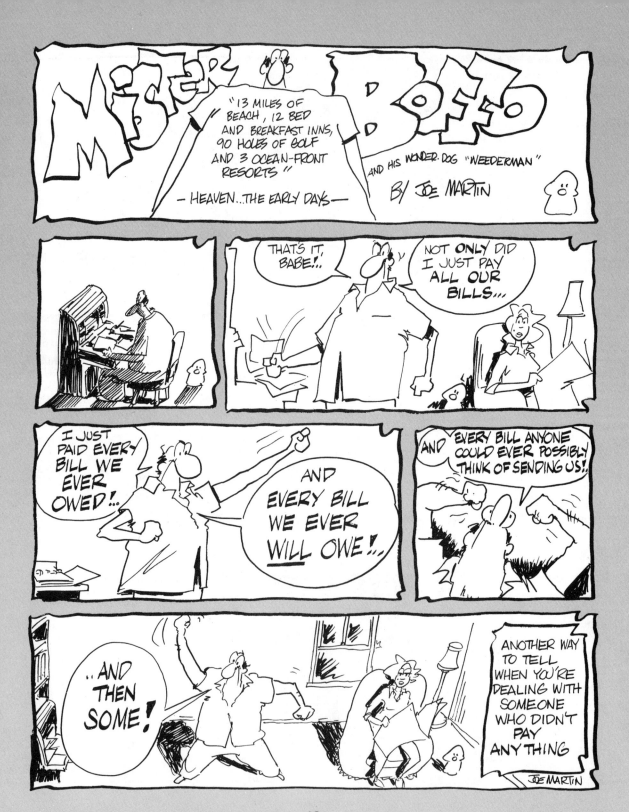

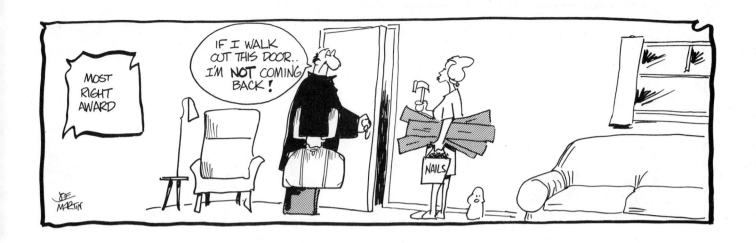

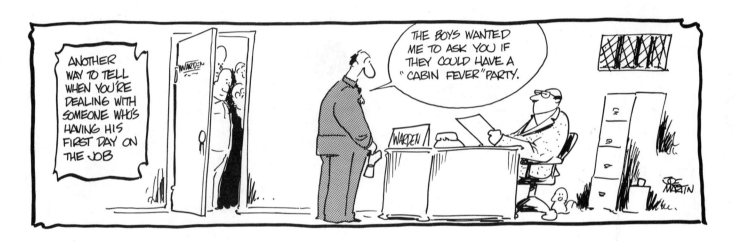

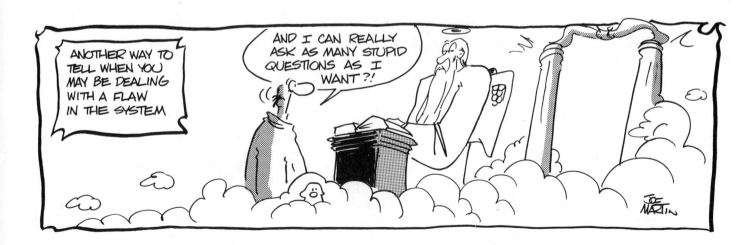

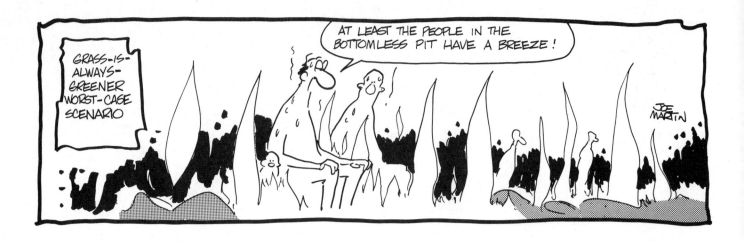

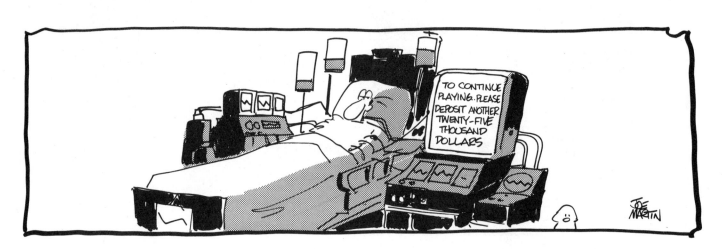

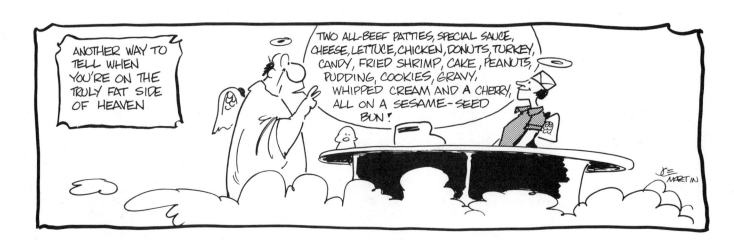

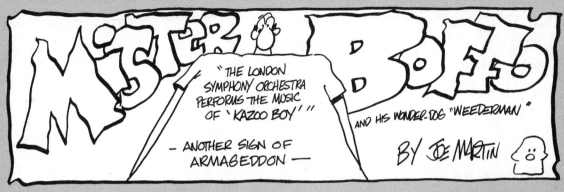

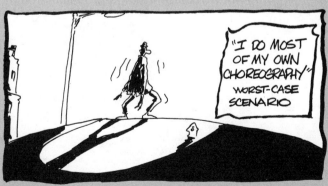

65

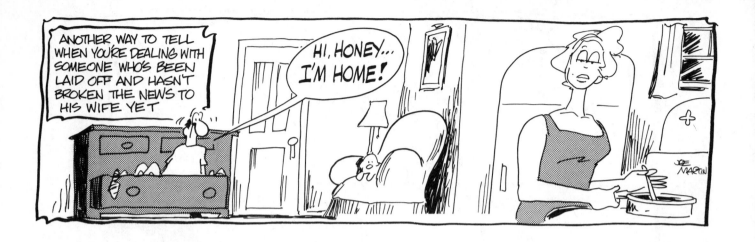

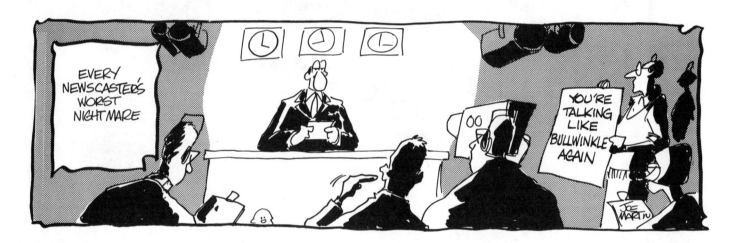

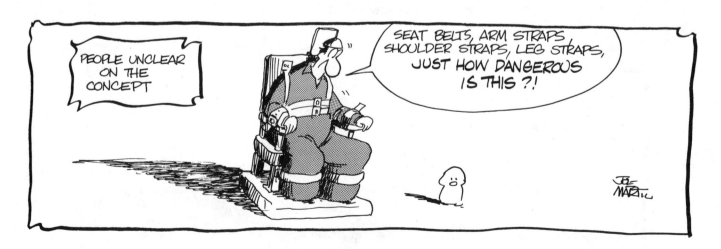

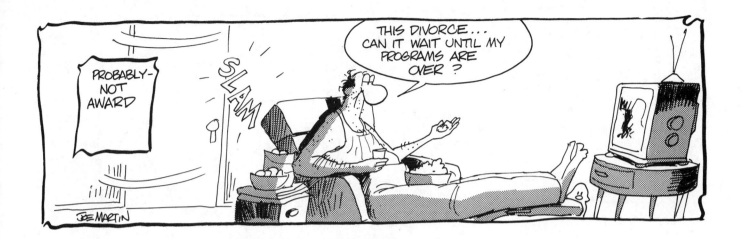

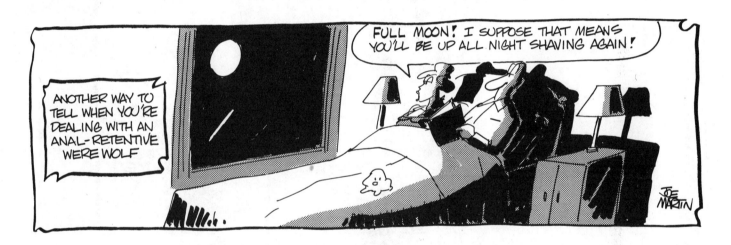

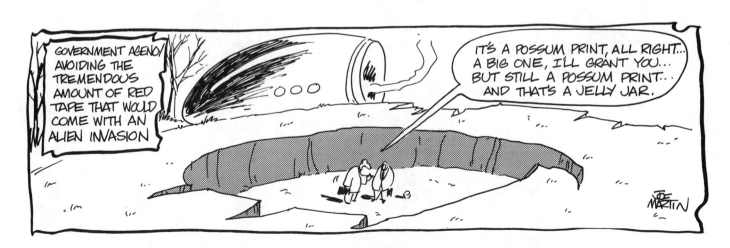

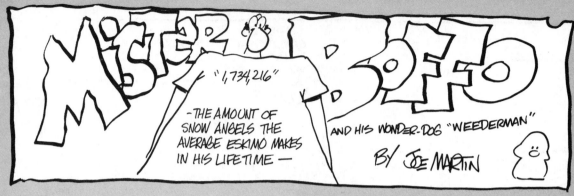

# Mister Boffo

"1,734,216"

—THE AMOUNT OF SNOW ANGELS THE AVERAGE ESKIMO MAKES IN HIS LIFETIME—

AND HIS WONDER-DOG "WEEDERMAN"

BY JOE MARTIN

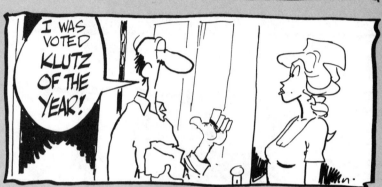

I WAS VOTED KLUTZ OF THE YEAR!

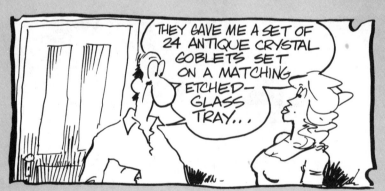

THEY GAVE ME A SET OF 24 ANTIQUE CRYSTAL GOBLETS SET ON A MATCHING ETCHED—GLASS TRAY...

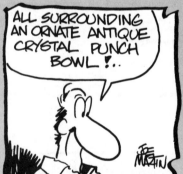

ALL SURROUNDING AN ORNATE ANTIQUE CRYSTAL PUNCH BOWL!..

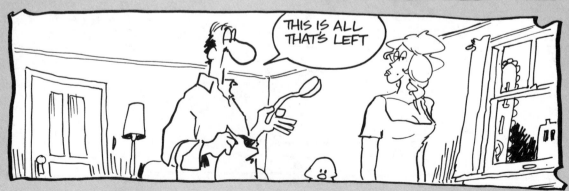

THIS IS ALL THAT'S LEFT

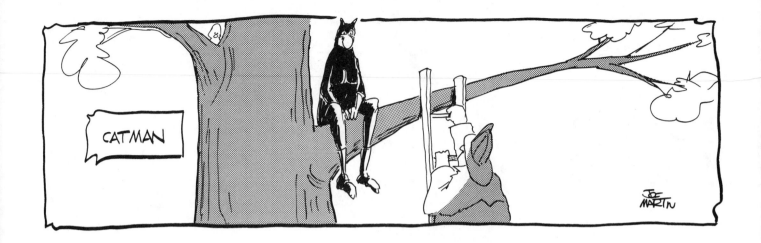

CATMAN

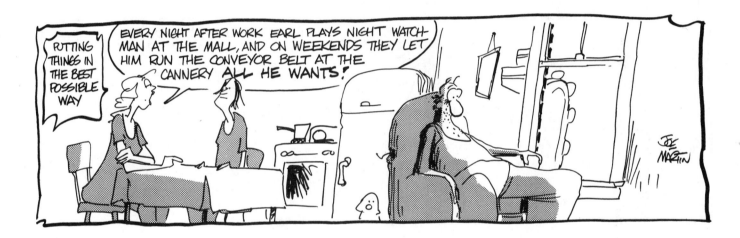

PUTTING THINGS IN THE BEST POSSIBLE WAY

EVERY NIGHT AFTER WORK EARL PLAYS NIGHT WATCHMAN AT THE MALL, AND ON WEEKENDS THEY LET HIM RUN THE CONVEYOR BELT AT THE CANNERY ALL HE WANTS!

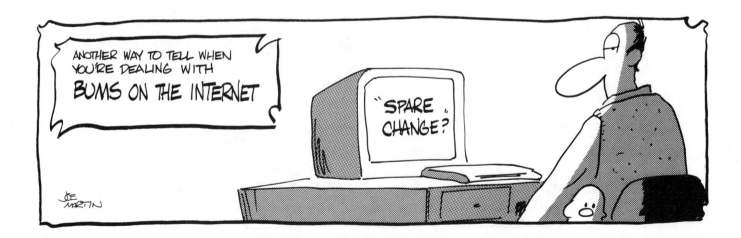

ANOTHER WAY TO TELL WHEN YOU'RE DEALING WITH BUMS ON THE INTERNET

"SPARE CHANGE?"

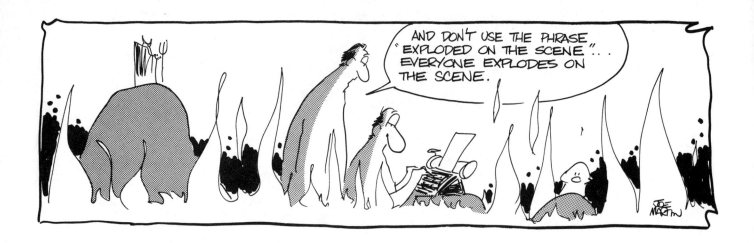

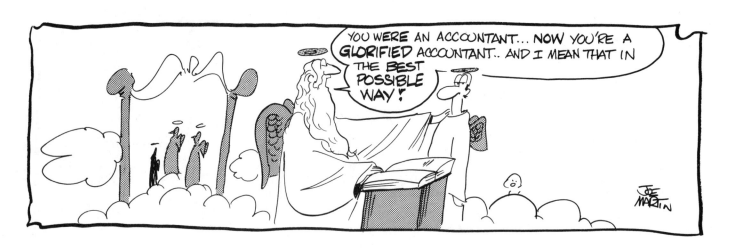

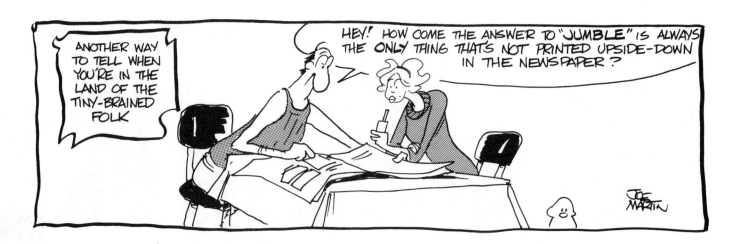

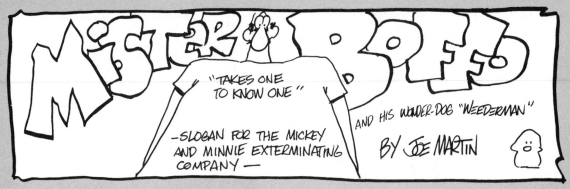

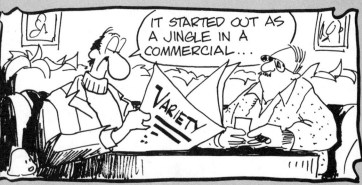

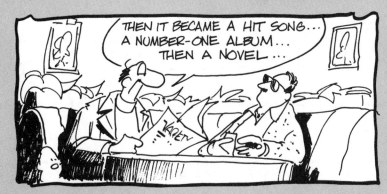

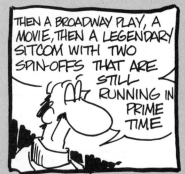

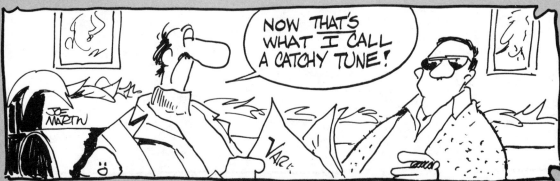

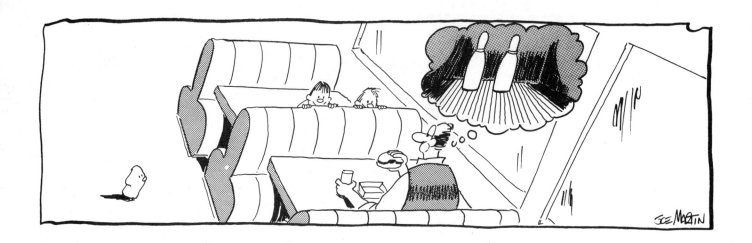

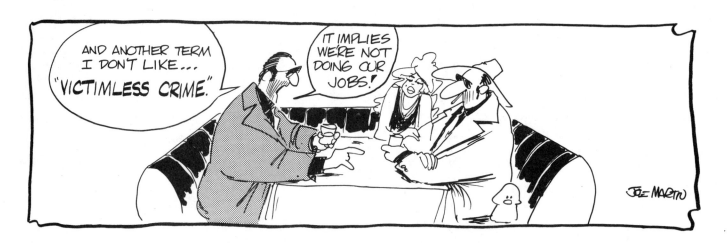

AND ANOTHER TERM I DON'T LIKE... "VICTIMLESS CRIME."

IT IMPLIES WE'RE NOT DOING OUR JOBS!

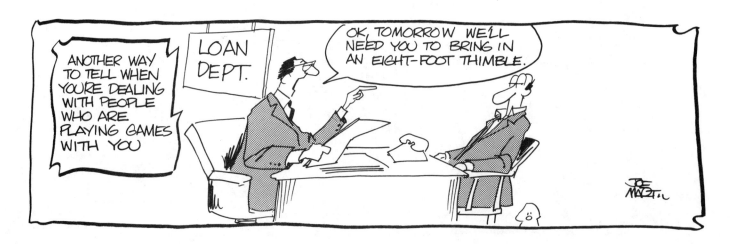

ANOTHER WAY TO TELL WHEN YOU'RE DEALING WITH PEOPLE WHO ARE PLAYING GAMES WITH YOU

LOAN DEPT.

OK, TOMORROW WE'LL NEED YOU TO BRING IN AN EIGHT-FOOT THIMBLE.

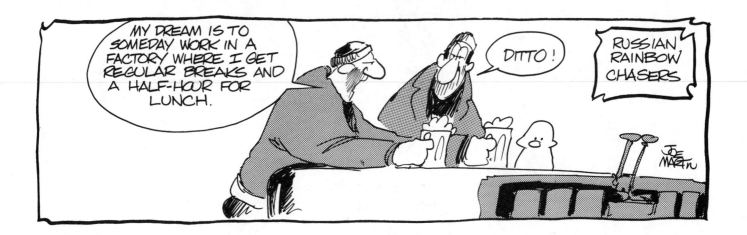

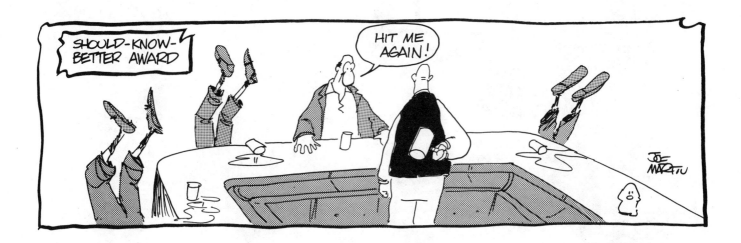

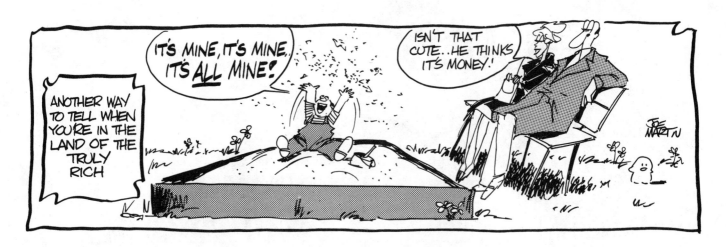

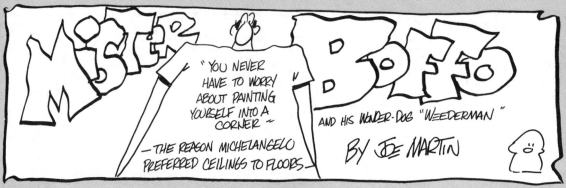

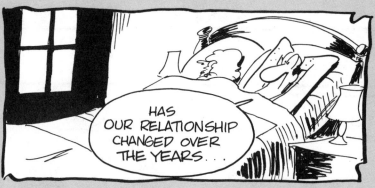

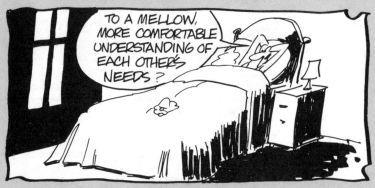
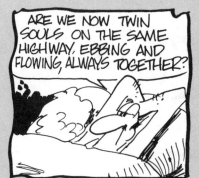

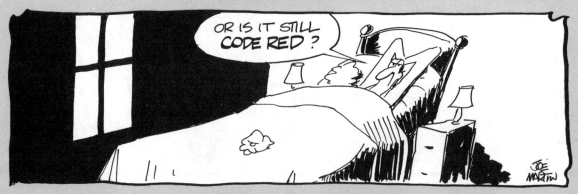

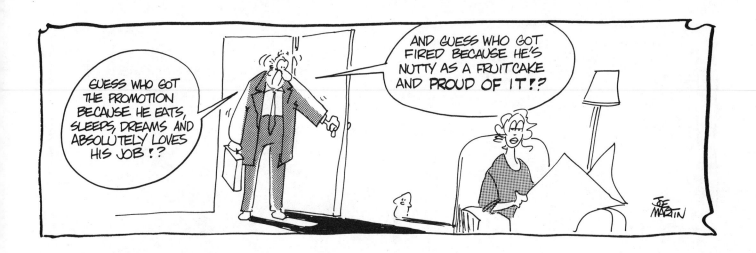

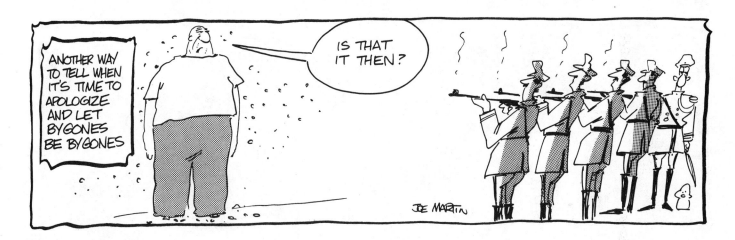

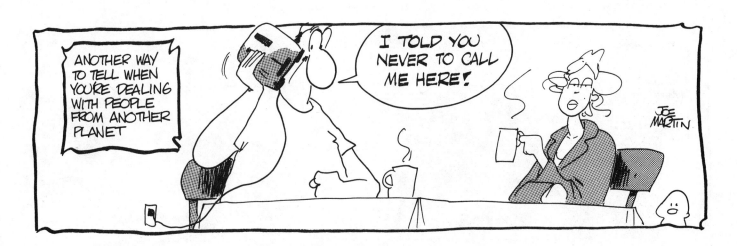

# Mister Boffo

"THE 'ALTERNATOR'" — MESSENGER FROM THE FUTURE SENT BACK IN TIME TO CHANGE THE DESTINY OF THE WORLD BY GETTING A CAR STARTED

AND HIS WONDER-DOG "WEEDERMAN"

BY JOE MARTIN

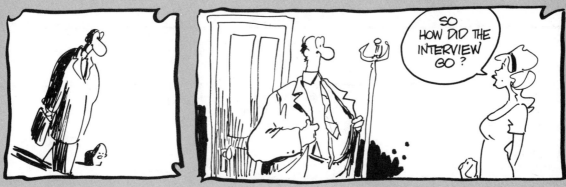

SO HOW DID THE INTERVIEW GO?

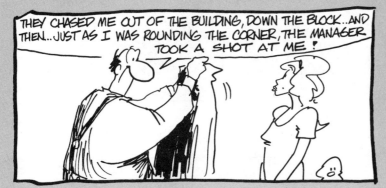

THEY CHASED ME OUT OF THE BUILDING, DOWN THE BLOCK...AND THEN...JUST AS I WAS ROUNDING THE CORNER, THE MANAGER TOOK A SHOT AT ME!

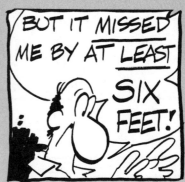

BUT IT MISSED ME BY AT LEAST SIX FEET!

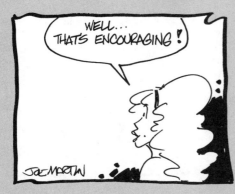

WELL... THAT'S ENCOURAGING!

JOE MARTIN

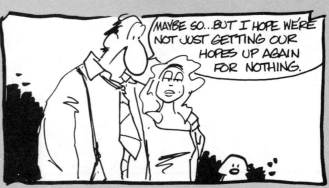

MAYBE SO...BUT I HOPE WE'RE NOT JUST GETTING OUR HOPES UP AGAIN FOR NOTHING.

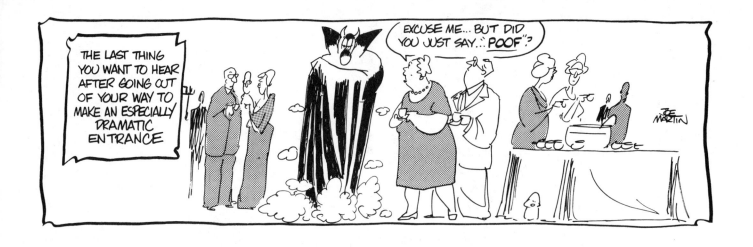

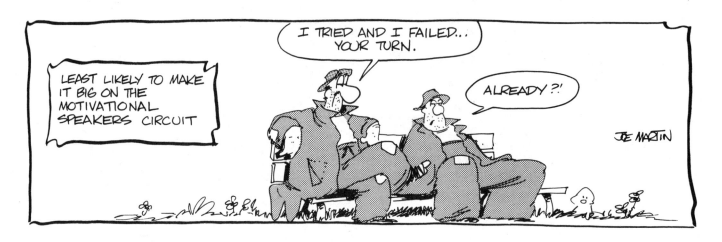

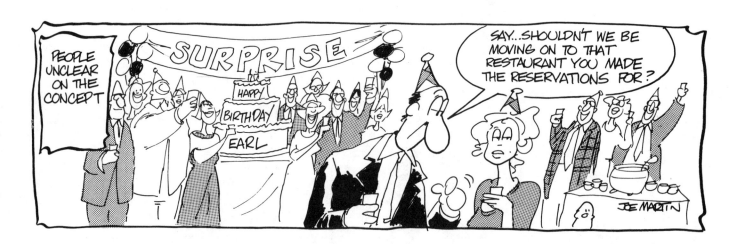

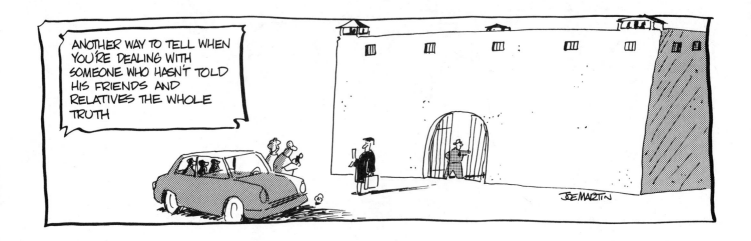

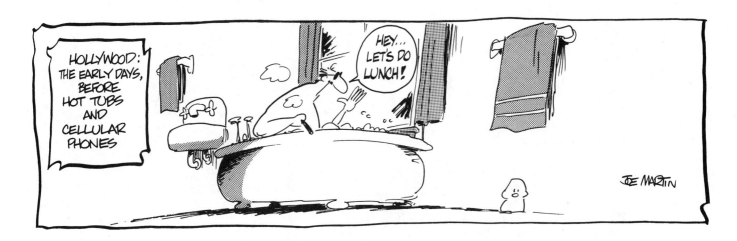

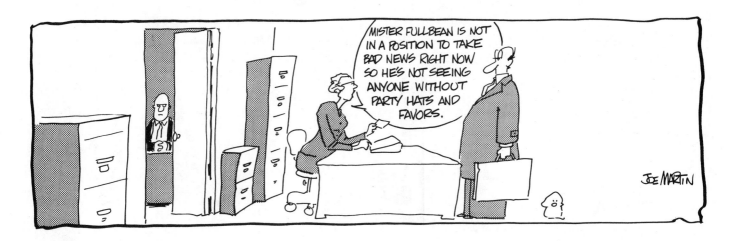

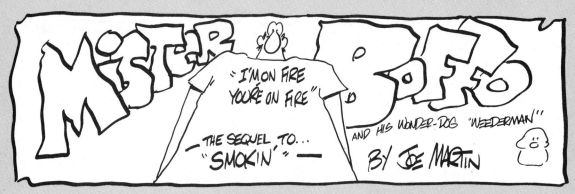

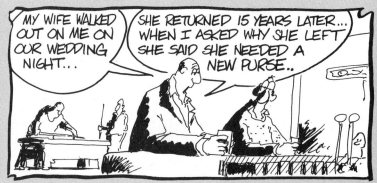

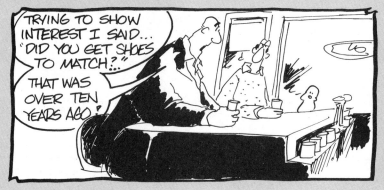

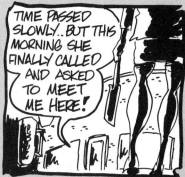

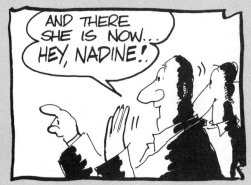

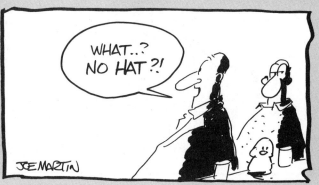

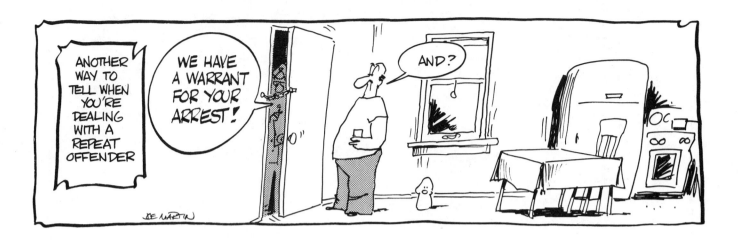

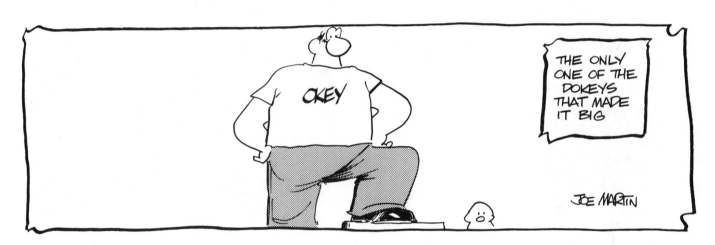

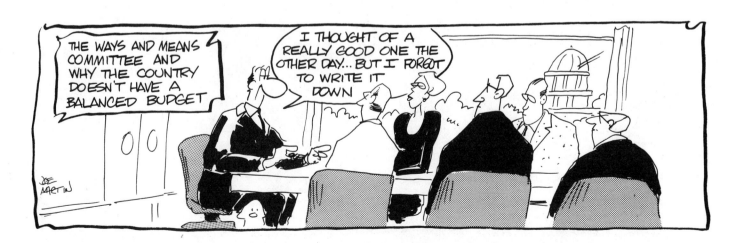

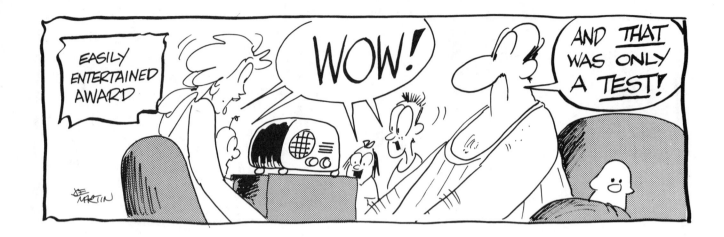

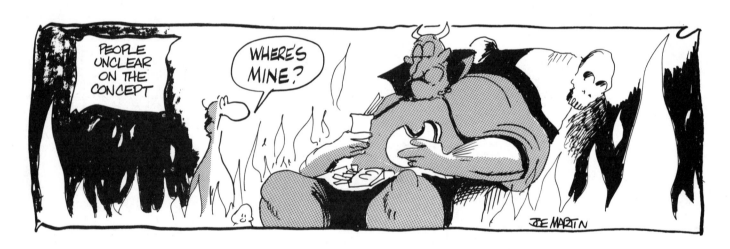

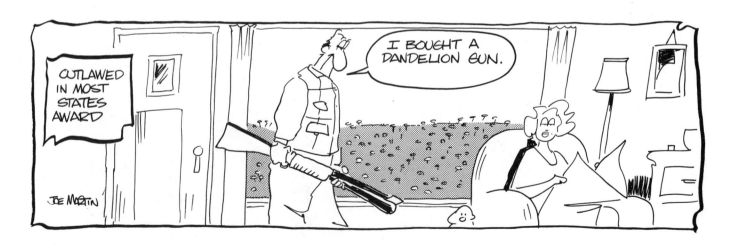

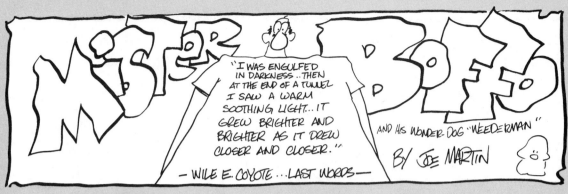

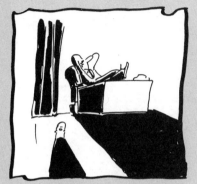

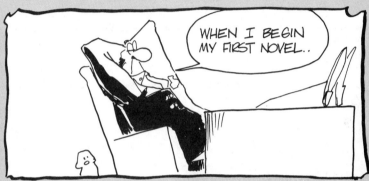

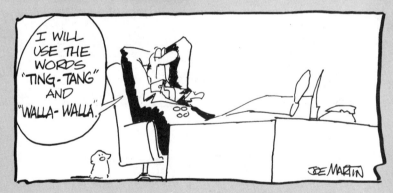

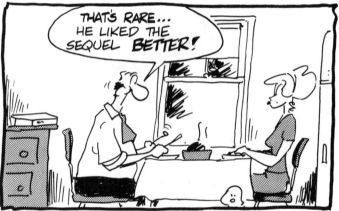

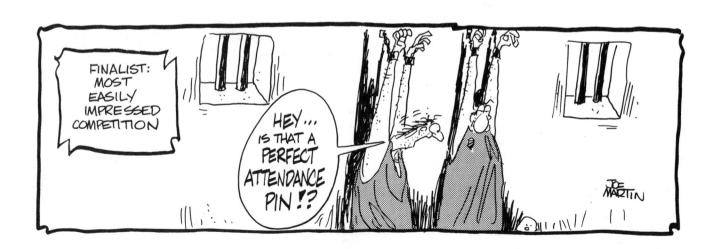

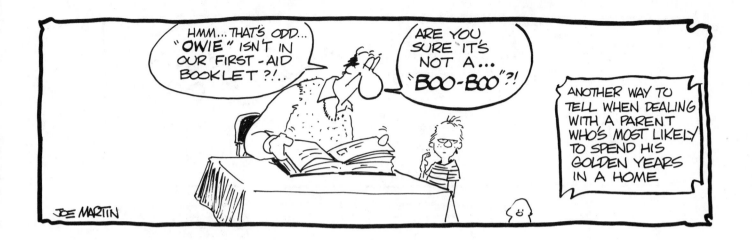

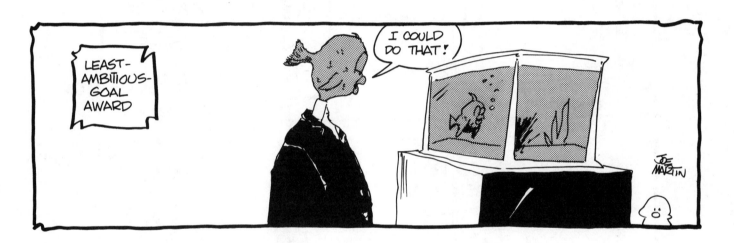

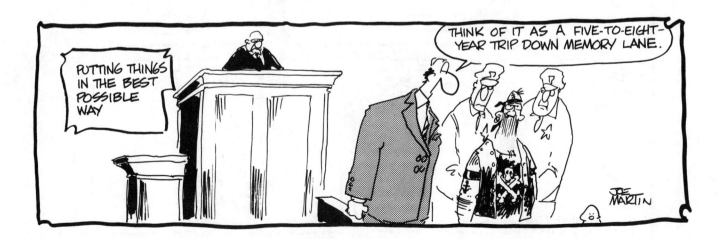

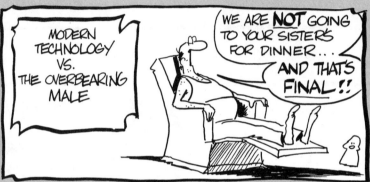

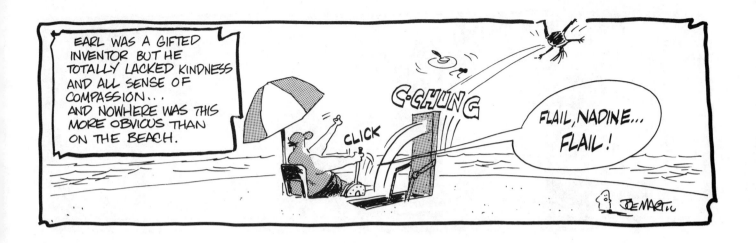

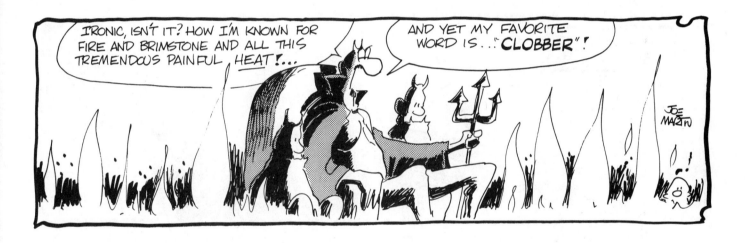

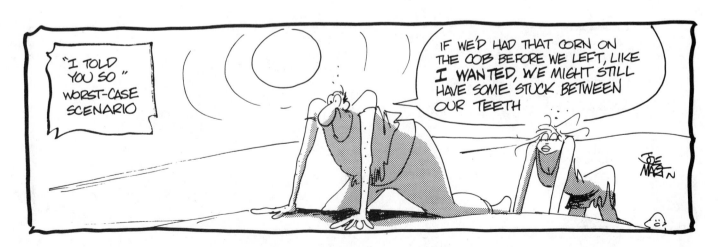

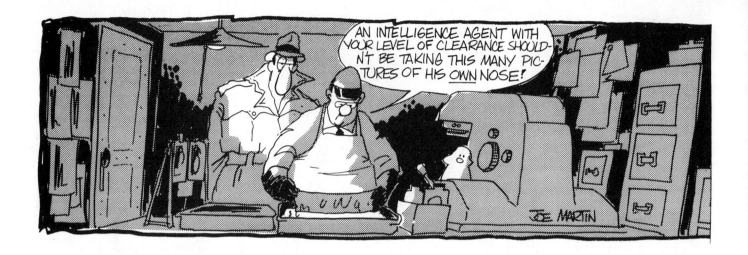

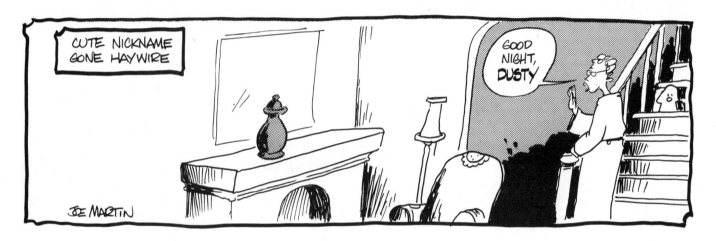

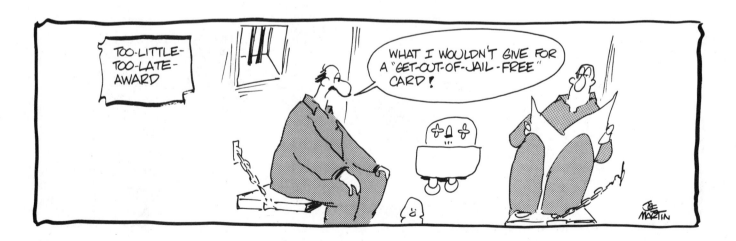

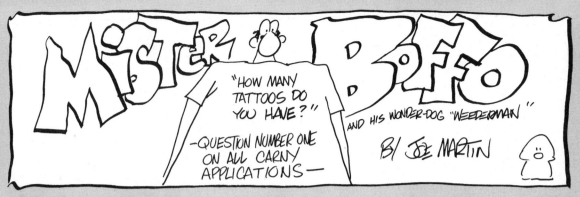

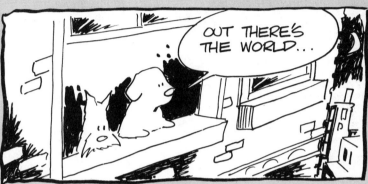

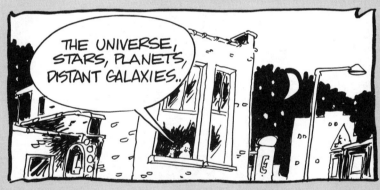

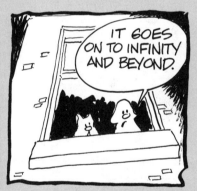

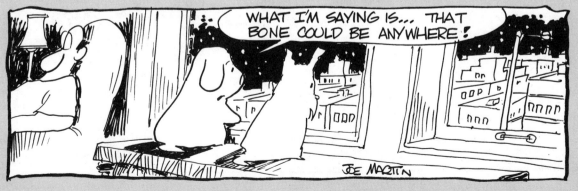

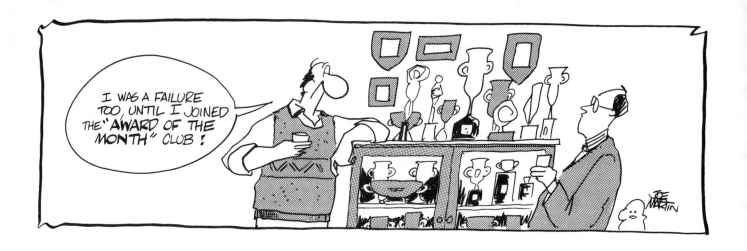

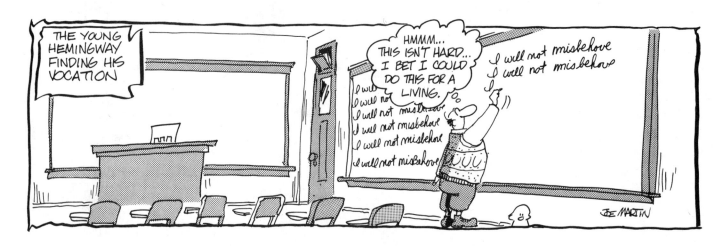

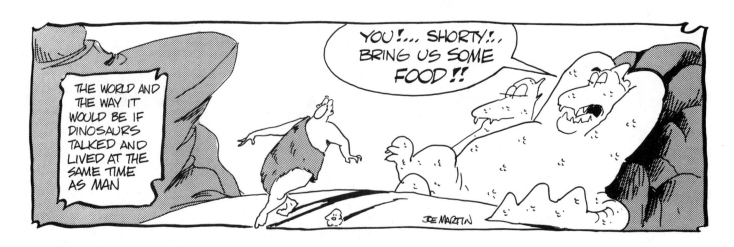

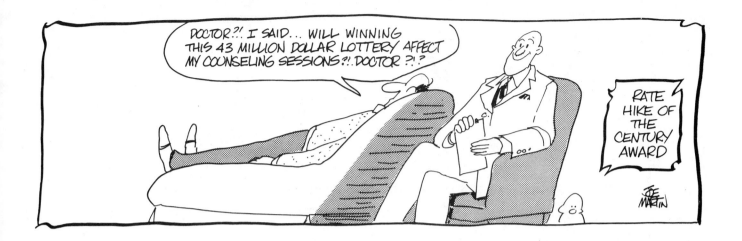

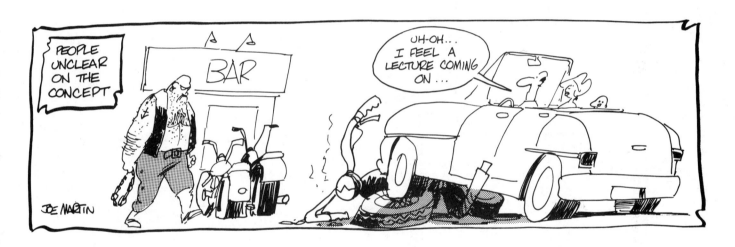

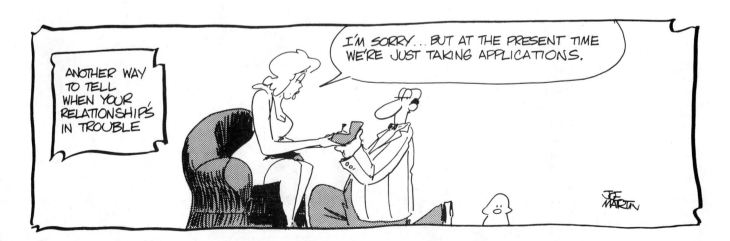

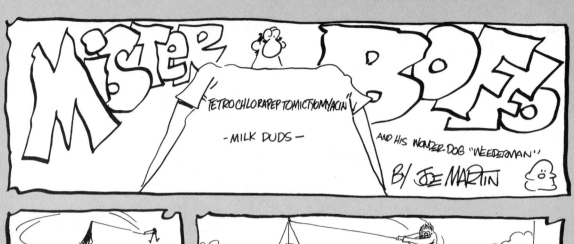

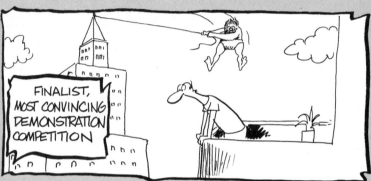

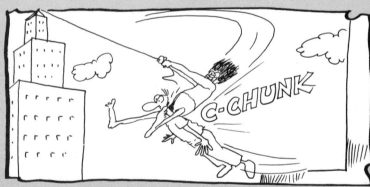
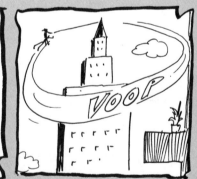

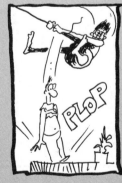
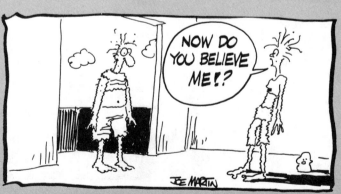

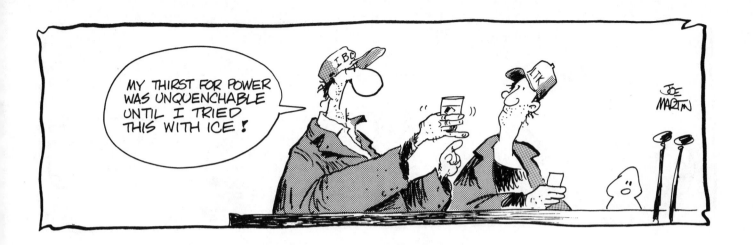

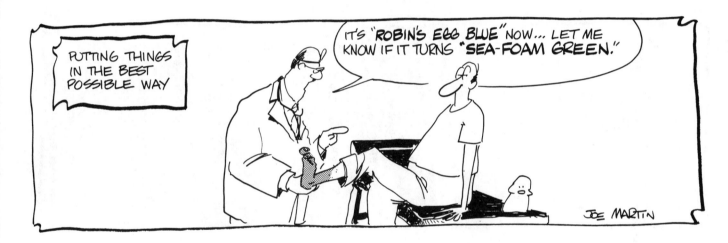

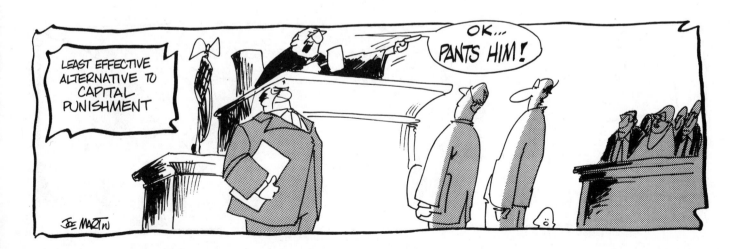

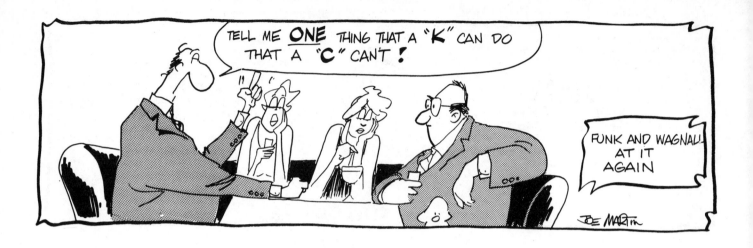

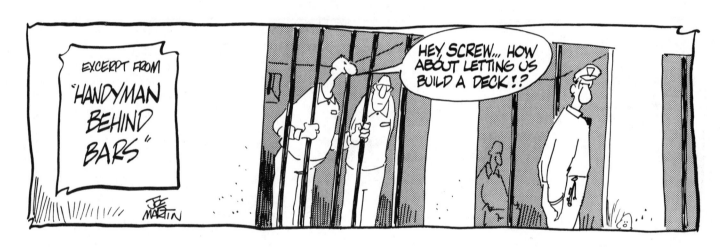

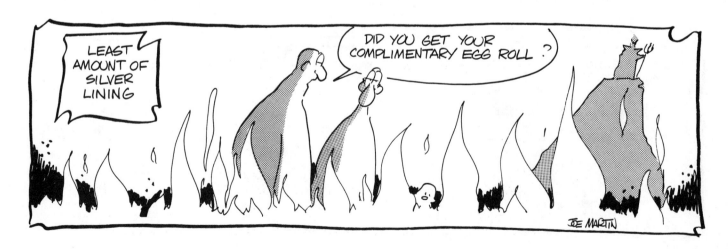

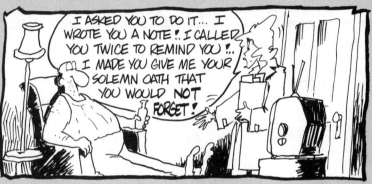

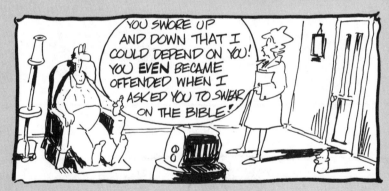

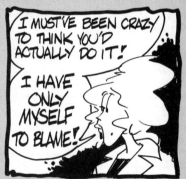

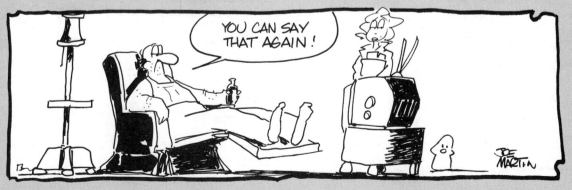

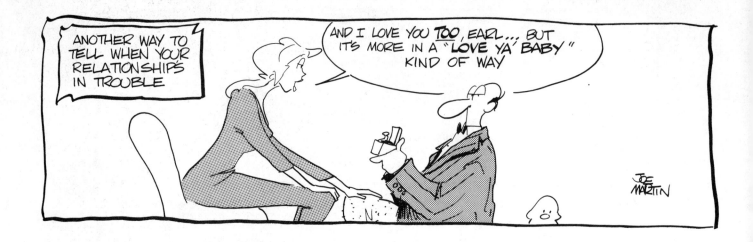

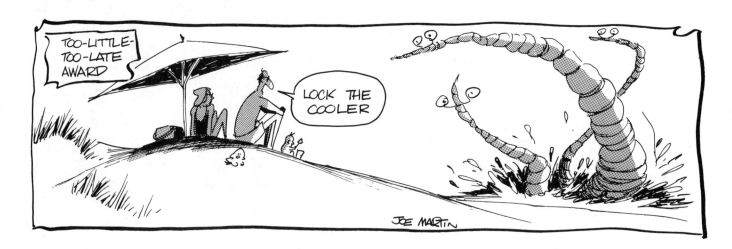

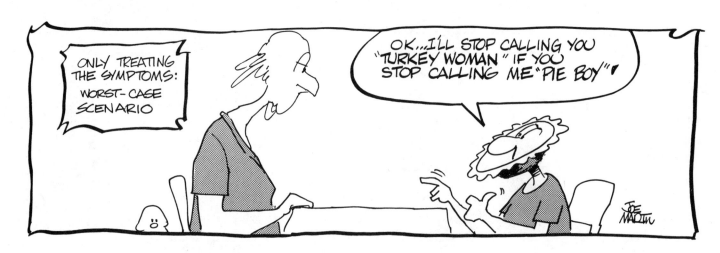

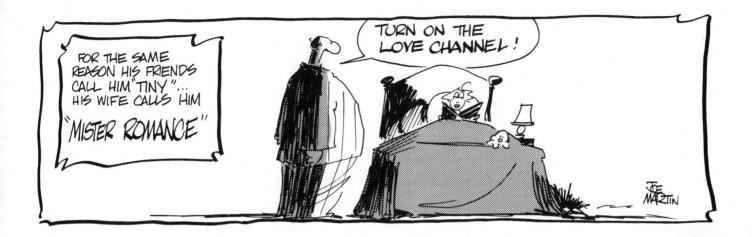

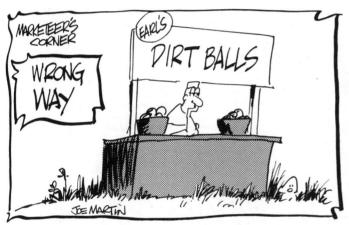

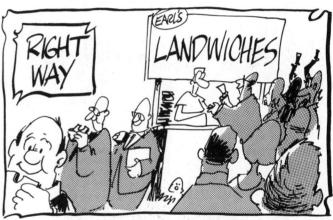

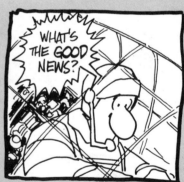

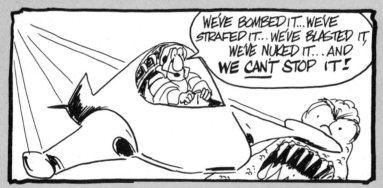

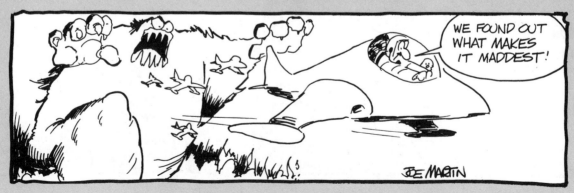

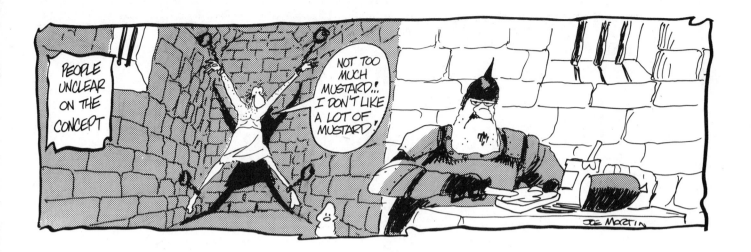

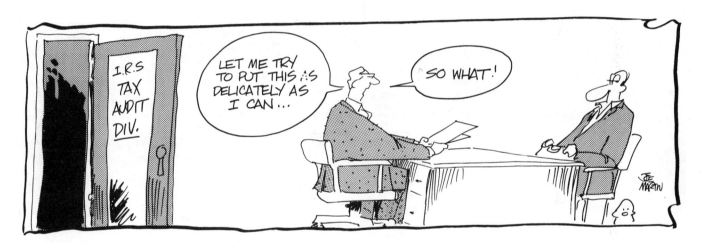

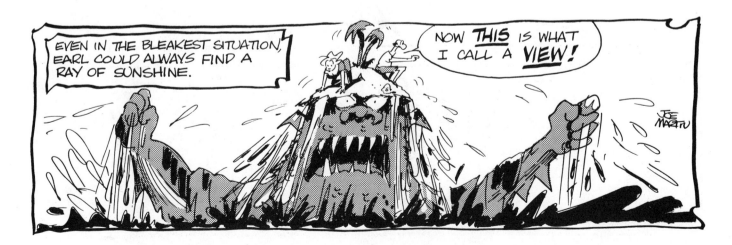

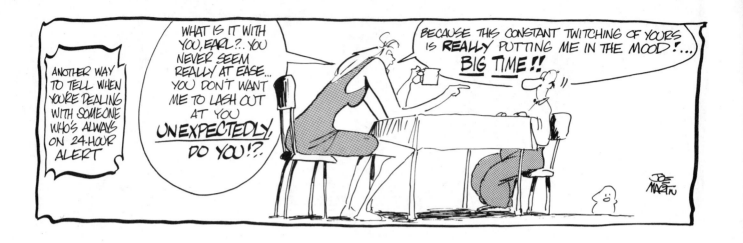

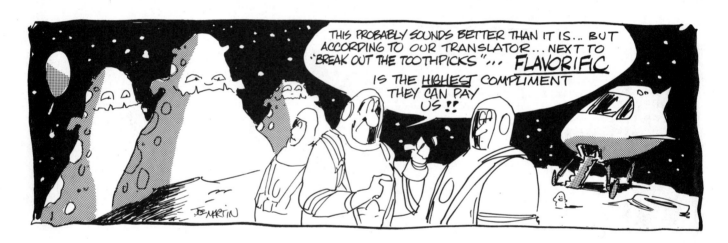

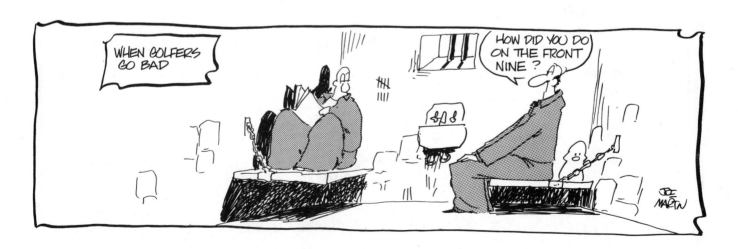

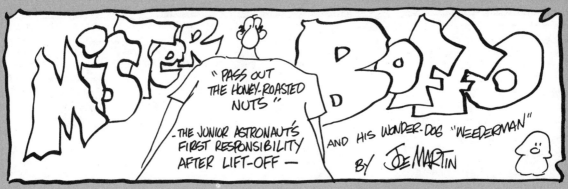

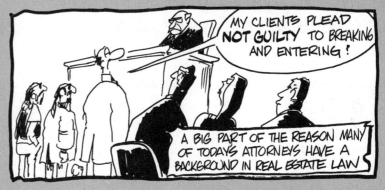

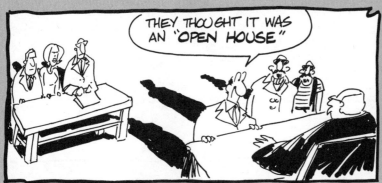

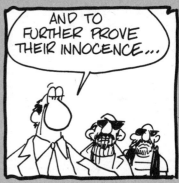

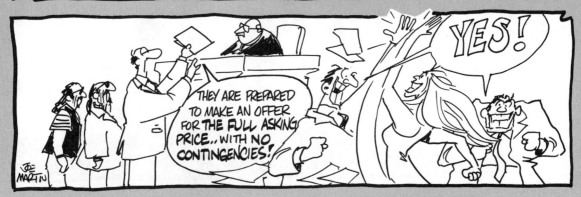

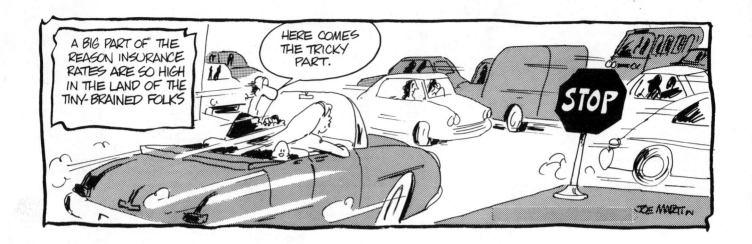

A BIG PART OF THE REASON INSURANCE RATES ARE SO HIGH IN THE LAND OF THE TINY-BRAINED FOLKS

HERE COMES THE TRICKY PART.

STOP

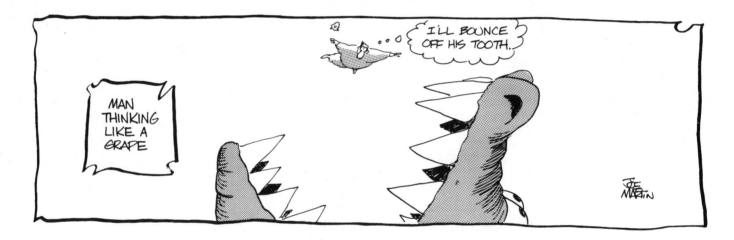

MAN THINKING LIKE A GRAPE

I'LL BOUNCE OFF HIS TOOTH.

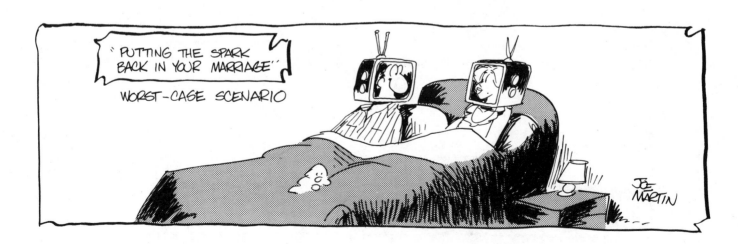

"PUTTING THE SPARK BACK IN YOUR MARRIAGE"

WORST-CASE SCENARIO

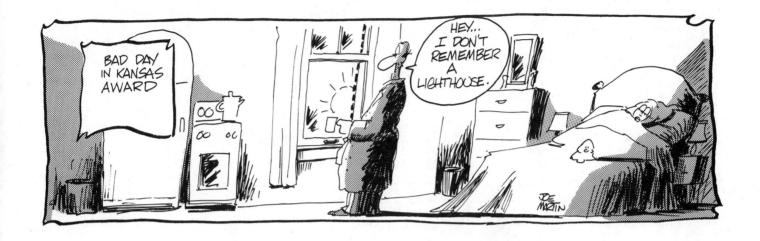

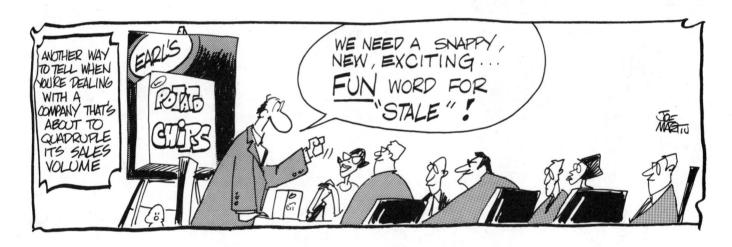

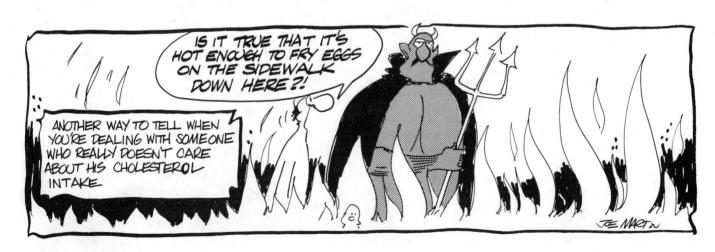

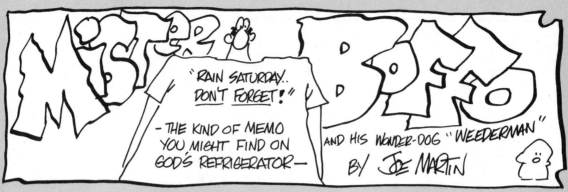

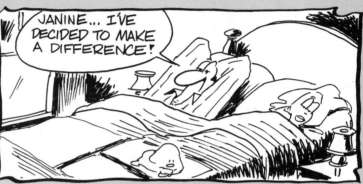

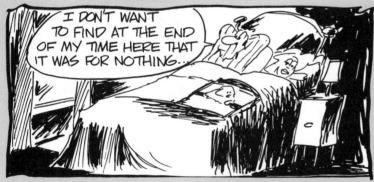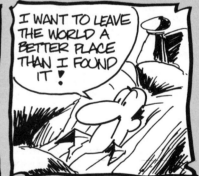

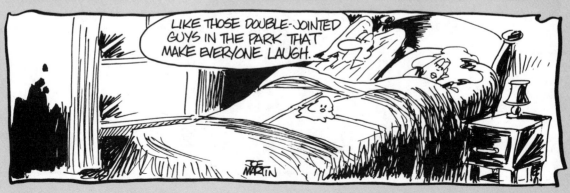

104

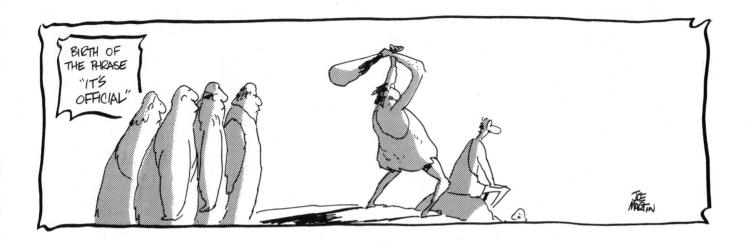

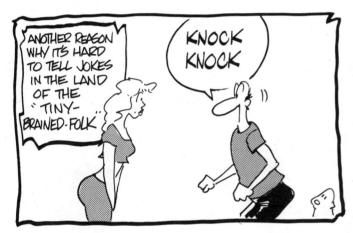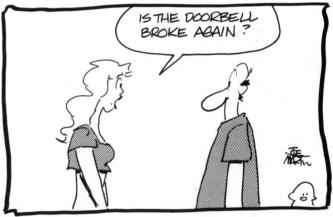

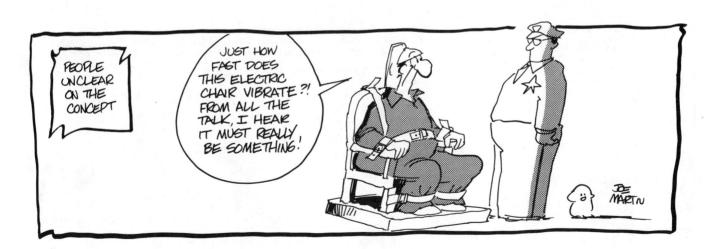

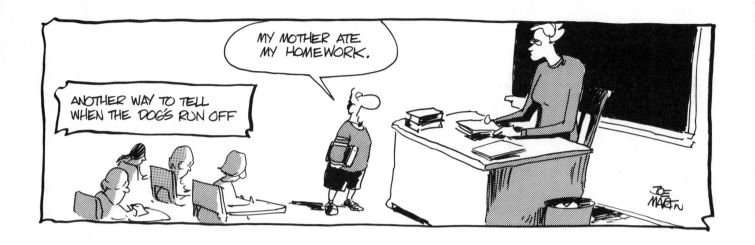

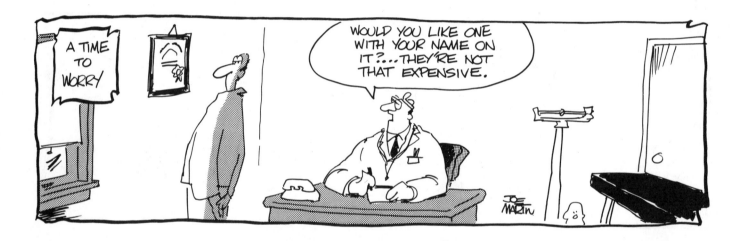

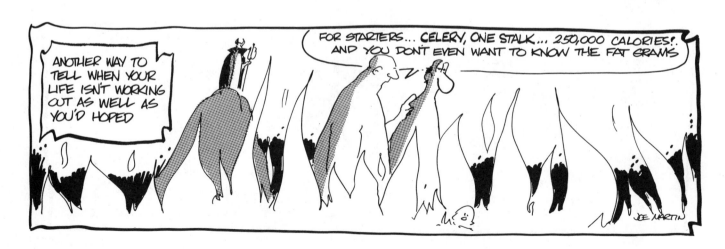

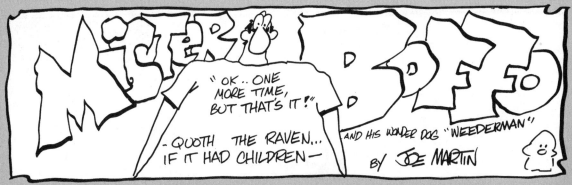

MISTER BOFFO

"OK.. ONE MORE TIME, BUT THAT'S IT!"

— QUOTH THE RAVEN... IF IT HAD CHILDREN —

AND HIS WONDER DOG "WEEDERMAN"

BY JOE MARTIN

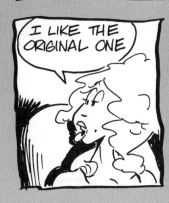

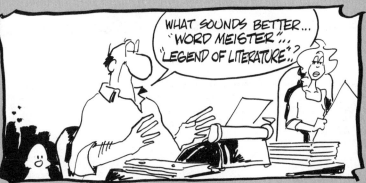

WHAT SOUNDS BETTER... "WORD MEISTER"... "LEGEND OF LITERATURE"...?

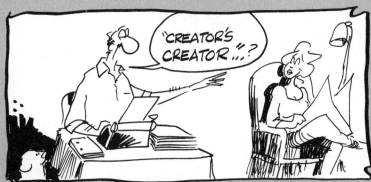

"CREATOR'S CREATOR"...?

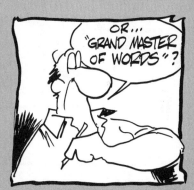

OR... "GRAND MASTER OF WORDS"?

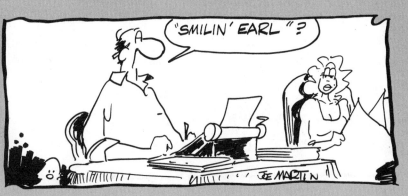

I LIKE THE ORIGINAL ONE

"SMILIN' EARL"?

JOE MARTIN

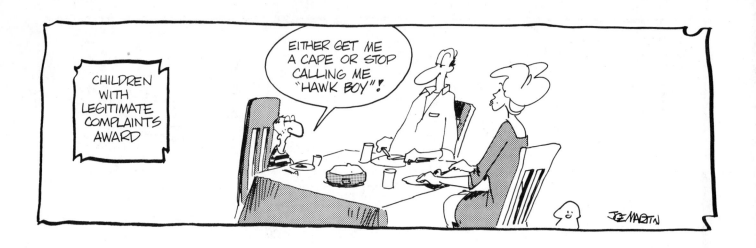

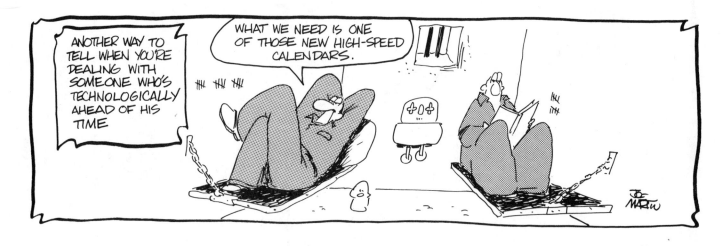

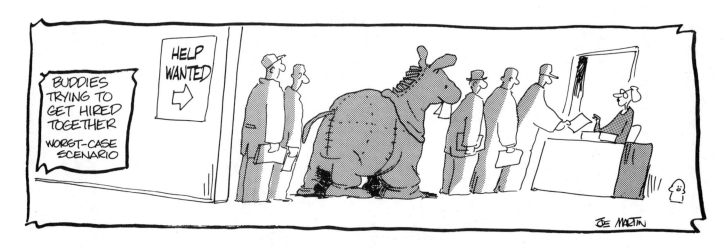

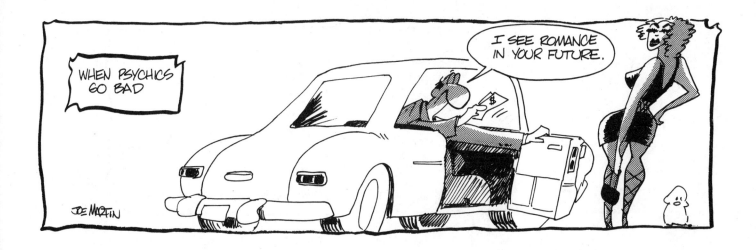

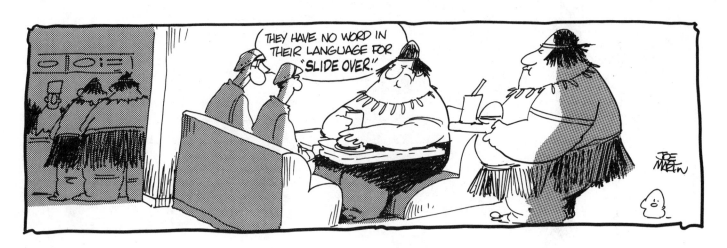

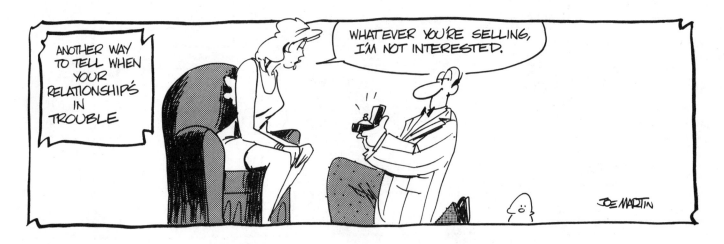

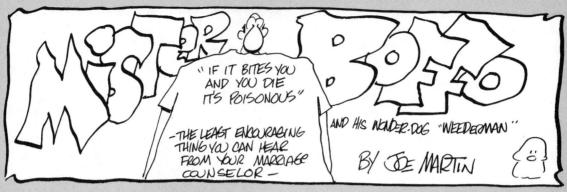

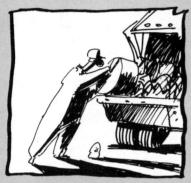

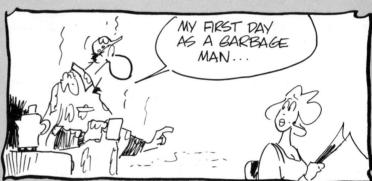

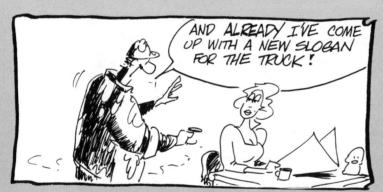

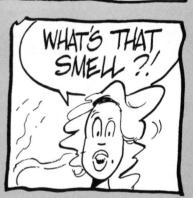

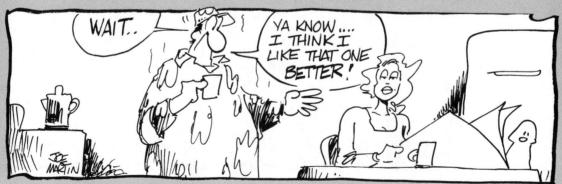

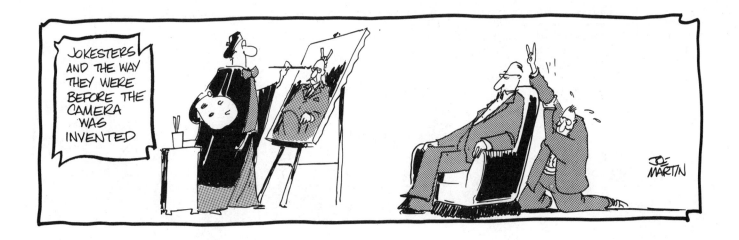

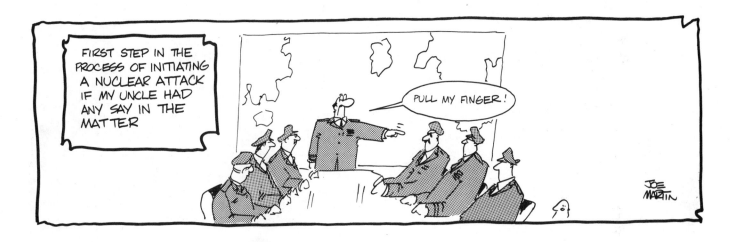

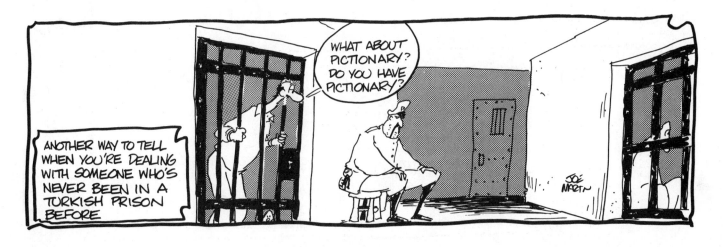

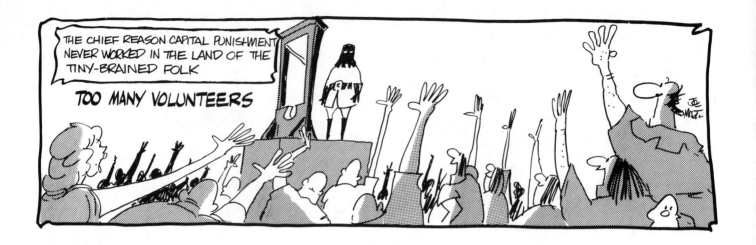

THE CHIEF REASON CAPITAL PUNISHMENT NEVER WORKED IN THE LAND OF THE TINY-BRAINED FOLK

*TOO MANY VOLUNTEERS*

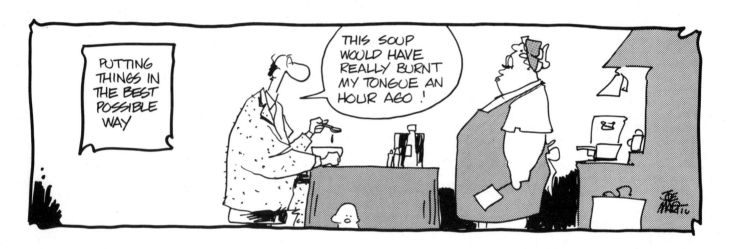

PUTTING THINGS IN THE BEST POSSIBLE WAY

THIS SOUP WOULD HAVE REALLY BURNT MY TONGUE AN HOUR AGO !

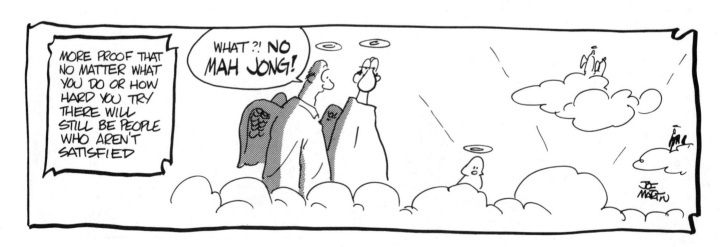

MORE PROOF THAT NO MATTER WHAT YOU DO OR HOW HARD YOU TRY THERE WILL STILL BE PEOPLE WHO AREN'T SATISFIED

WHAT ?! NO MAH JONG!

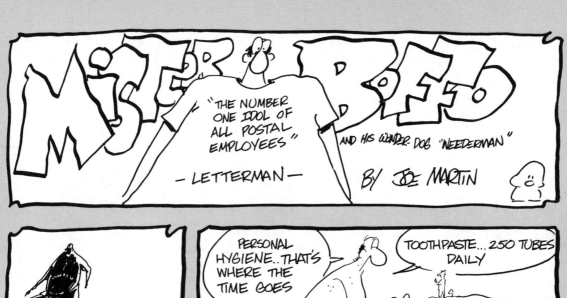

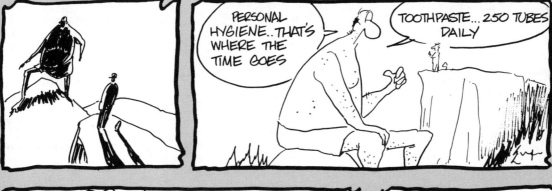

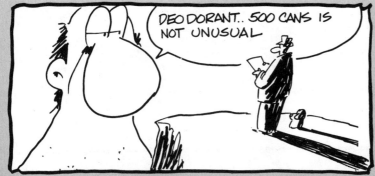

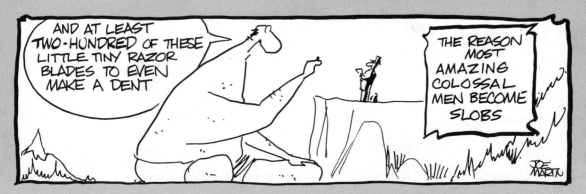

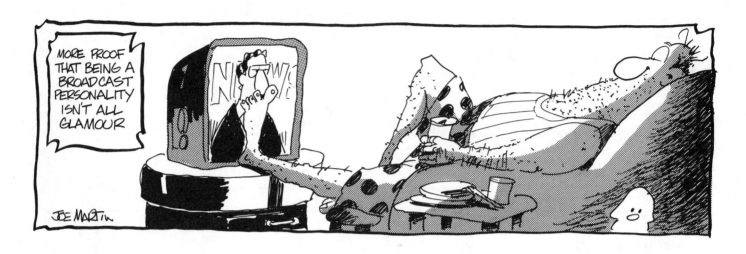

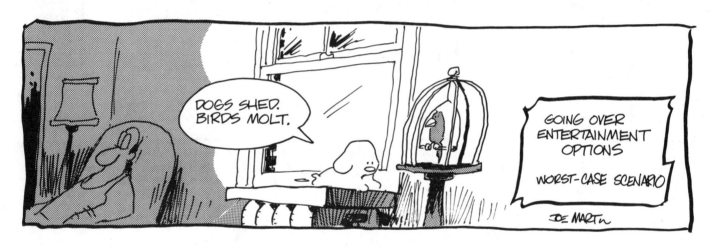

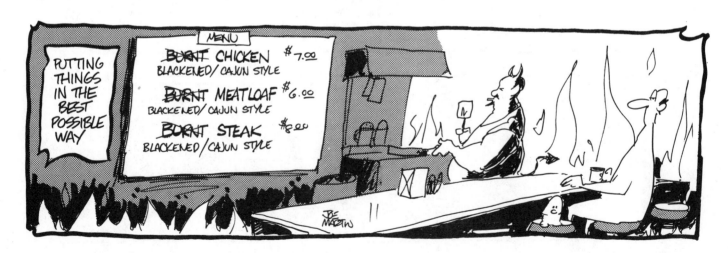

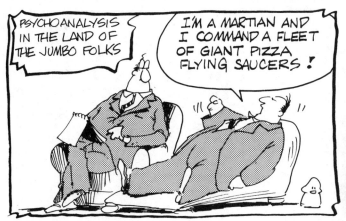

"SUMMER FUN"

— GOOD... BUT NOT THE BEST REASON TO GET MARRIED —

AND HIS WONDER-DOG "WEEDERMAN"

BY JOE MARTIN

NOW DON'T GET REAL EXCITED...

THIS PROBABLY SOUNDS BETTER THAN IT IS...

BUT... I'VE ESTABLISHED A LINE OF CREDIT...

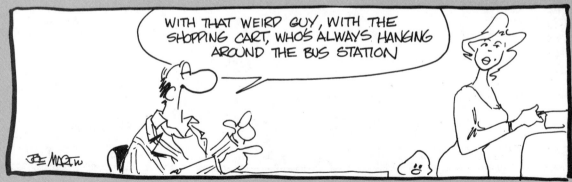

WITH THAT WEIRD GUY, WITH THE SHOPPING CART, WHO'S ALWAYS HANGING AROUND THE BUS STATION

JOE MARTIN

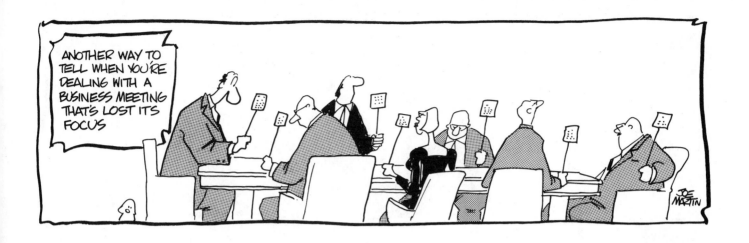

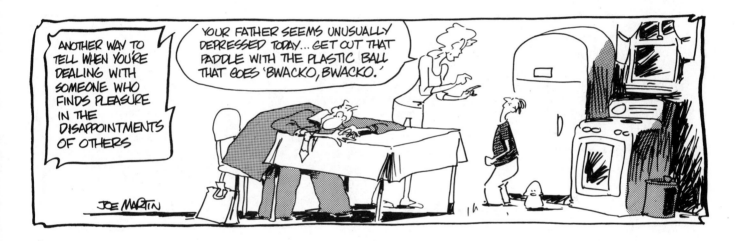

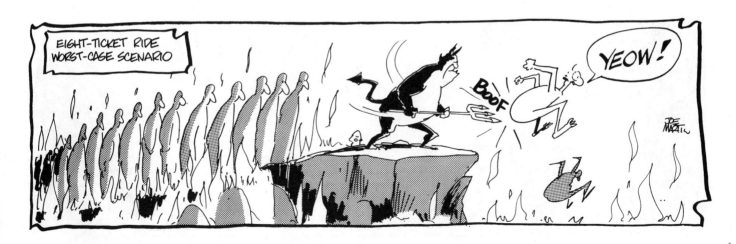

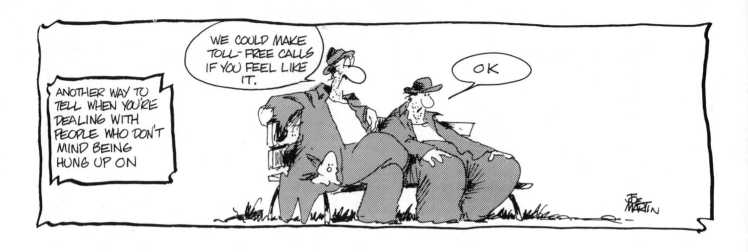

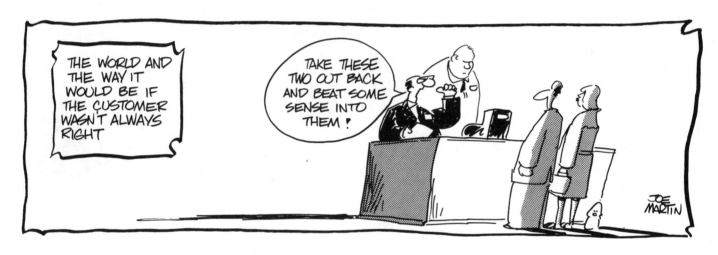

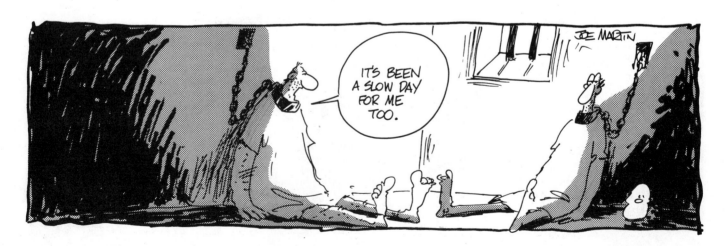

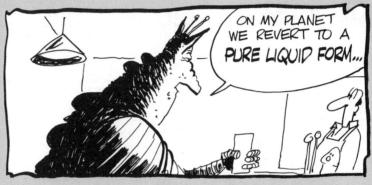

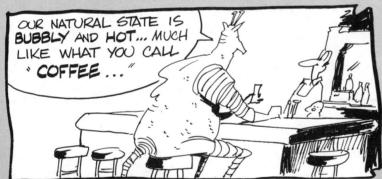

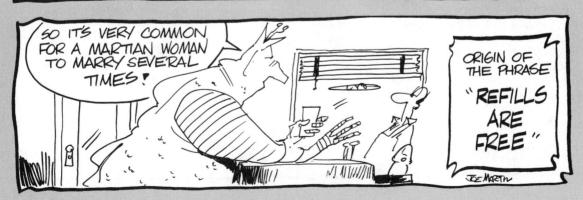

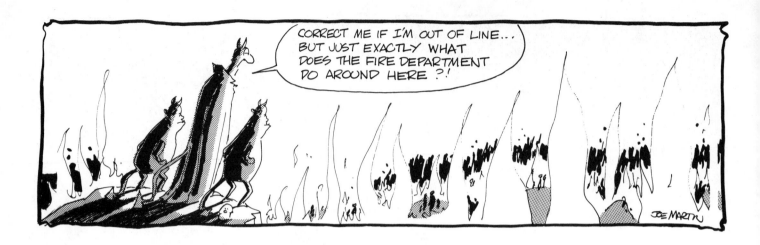

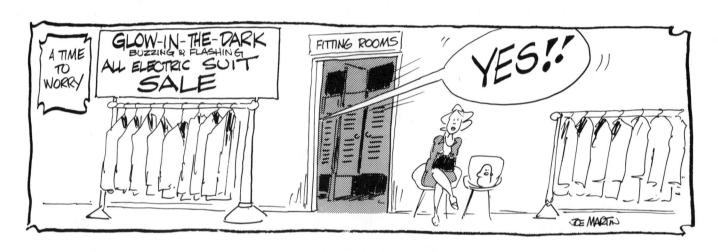

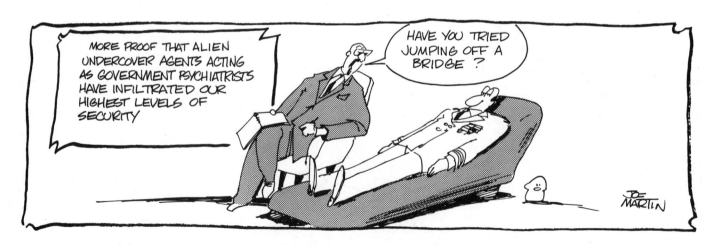

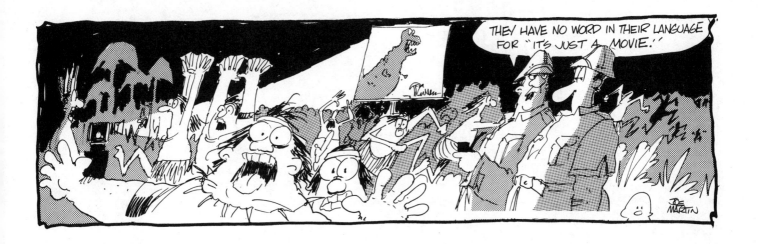

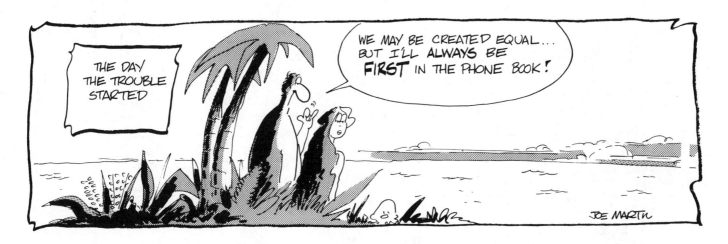

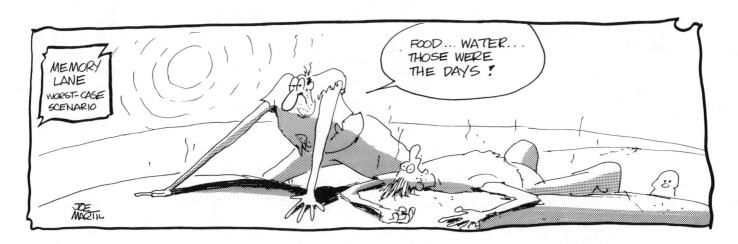

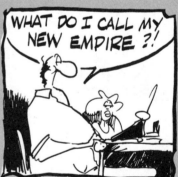

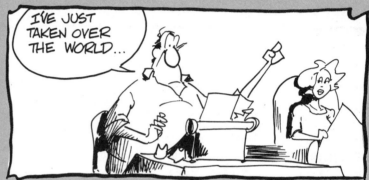

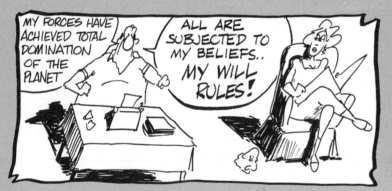

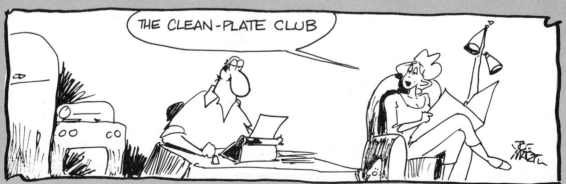

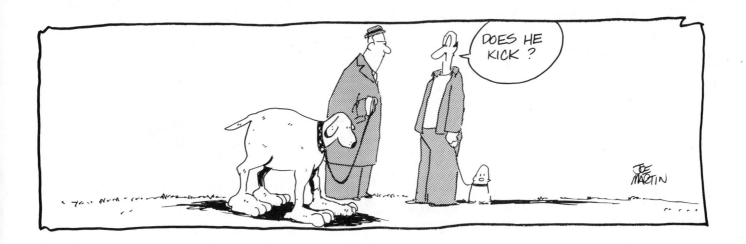

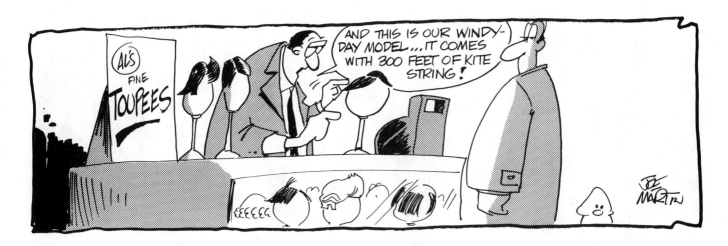

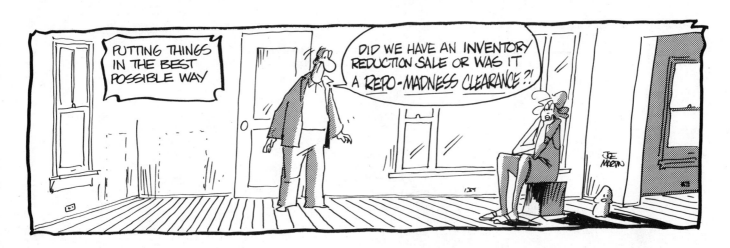

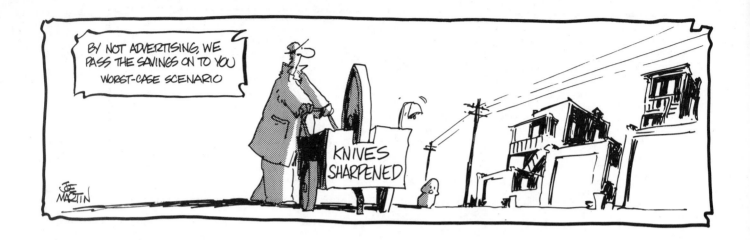

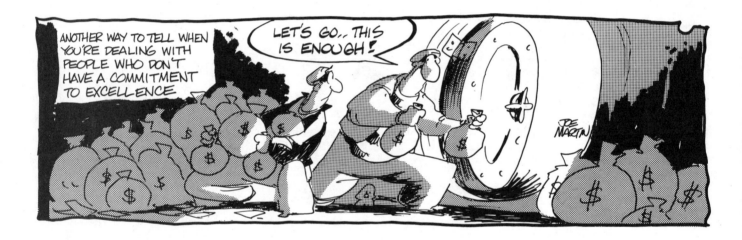

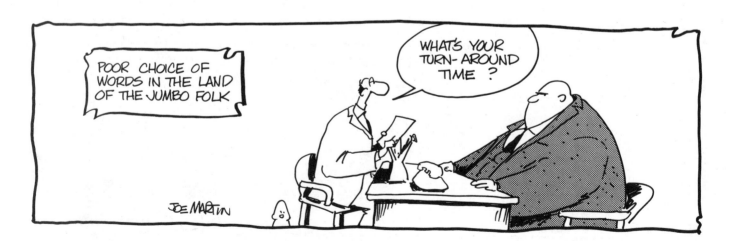

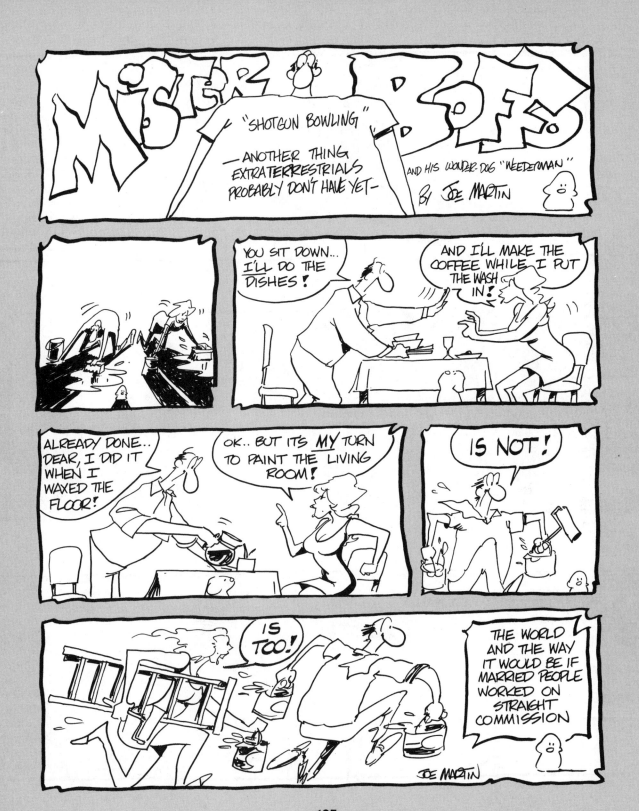

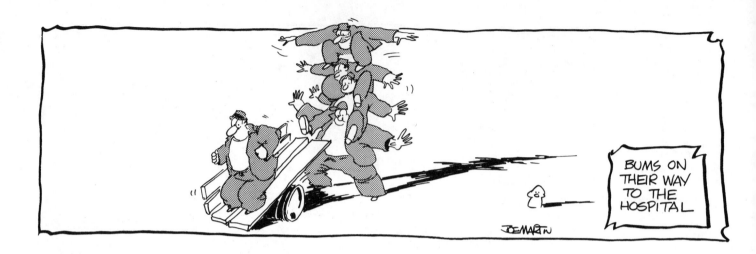

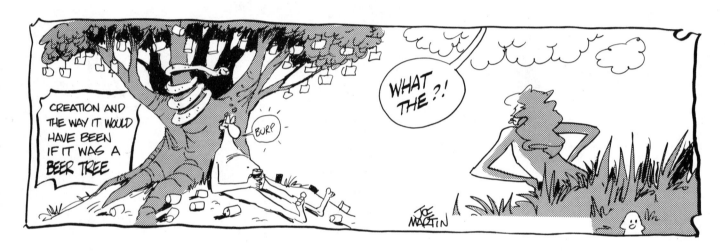

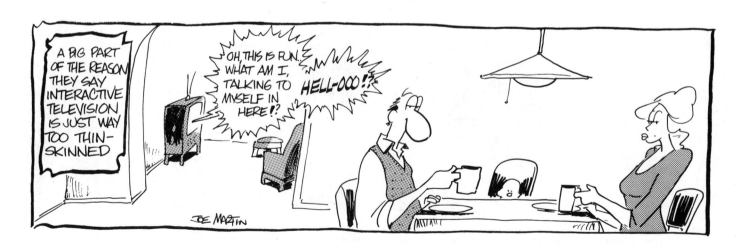

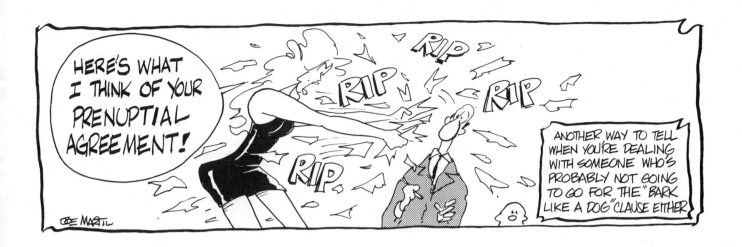

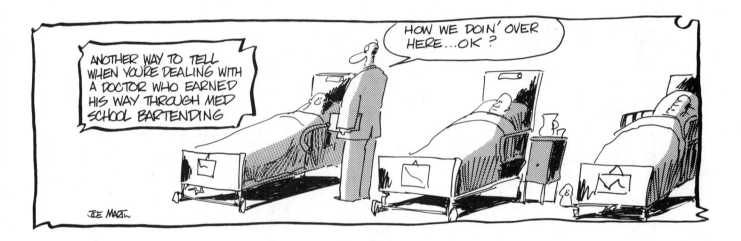

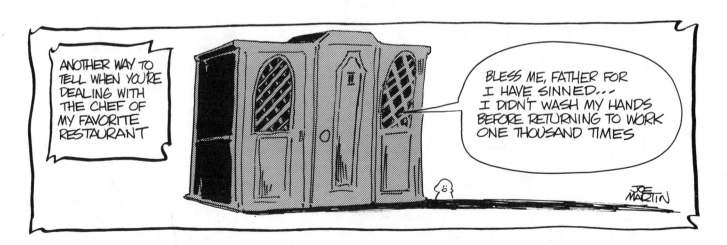

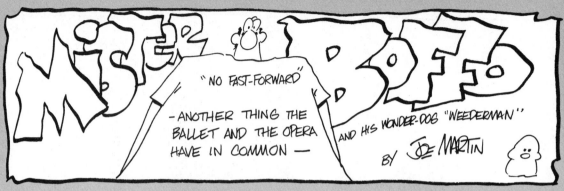